National Geographic Photographer's Field Guide

by Albert Moldvay

With contributions from the
photographers of the
National Geographic Society

Contents

Picture Thinking

4	Picture Planning	
6	Seeing in Two Dimensions	
7	The Right Light	Direction, hard versus soft light, color
10	The Right Angle	
11	Closing In	
12	Composition	

Mastering Your Camera

16	Cameras	Types and sizes
19	Loading Your Camera	
20	Holding Your Camera	
21	Choosing Your Film	ISOs, grain, pushing, color, black and white
26	Exposure	f-Stops, shutters, metering, 18% gray, f16 rule, bracketing
32	Focus and f-Stops	Depth of field, selective focus
35	Motion and Shutter Speeds	Stop-action, blurring, panning

After the Basics

38	Lenses	Normal, telephoto, multiplier, zoom, wide-angle, fisheye
44	Close-up Equipment	
46	Filters	
49	Tripods	
50	Flash	Exposure settings, guide numbers, automatic sensors, recharging, bounce flash, red-eye, flash reach

Popular Pictures

54	Activities Outdoors	Sports, parades, cookouts, hikes
57	Candids	
60	Celebrations	Parties, birthdays, graduations, holidays, weddings
66	Children and Babies	
68	Existing Light	Metering in dim light, interiors, fluorescent lighting, mixed lighting, stained glass, light beams
72	Houses and Buildings	

Copyright 1981, 1988, National Geographic Society, Washington, D. C. All rights reserved. Reproduction of the whole or any part of the contents without written permission is prohibited.
Second printing 1983. Revised edition 1988.
Library of Congress CIP data page 120

74	Landscapes	Viewpoint, lenses, horizons, time of day, sunsets, sun and sky
80	Nature	Rainbows, sunbursts, reflections on water, wildlife; close-ups of flowers, small creatures
86	Night Photography	Dusk lighting, cityscapes, fairs, neon signs, fireworks, lightning, the moon, star trails, light streaks
92	People and Portraits	Formal, informal, and environmental portraits; ways to relax your subjects; groups
98	Pets	
99	Special Situations	

Aerial Photography 99

Double Exposures 100

Show, Theater Shooting (& TV) 101

Snow, Rain, and Stormy Skies 102

Underwater Photography 104

Travel Photography

106	Getting Ready	What-to-shoot plan, what-to-take list
108	Setting Out	The X-ray question; how to survive customs
110	On the Road	What to look for; how to look for it
113	Camera Etiquette Around the World	
115	Coping With Climate	Cold and hot, damp and dust; the benefits of silica gel
116	Back Home	Preparing your slide show; storing your pictures
118	**Appendix: Camera and Film Care**	
		Maintenance and cleaning, equipment checks, batteries, film storage
120	Acknowledgments	

Tables

22	Color Films
24	Black and White Films
30	Don't Trust Your Meter
36	To Stop Action
46	Filters
68	Exposures for Existing Light
86	Night Exposures

Picture Thinking

**To Make
A Picture**

Photography may seem as simple as pushing a button, but most professionals say they "make," rather than take, pictures. Time, energy, experience, and often a lot of film go into photographs like those you see in National Geographic publications.

Yet you do not need six cameras, cases of film, and your own photographic laboratories and engravers to make fine pictures; you do need practice and care. You'll discover in this handbook basic and not-so-basic lessons about photography. And in the margins you'll find tips and tricks of the trade gathered from a host of National Geographic photographers.

**Picture
Planning**

An image doesn't start with a camera — it ends there. Once you release the shutter, the picture is recorded for better or worse. To get the picture you envision, you will have to make many choices

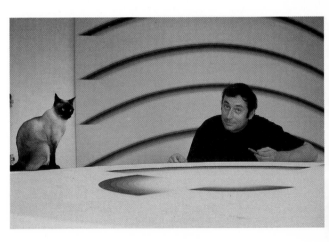

The bold colors alone would have made this a striking portrait, but by posing the artist's cat at the side, the photographer balanced his composition while repeating the motif of curved lines.

4

before you let the camera take over.

The first question to ask yourself is: Why am I taking this picture? The answer may be that you want a portrait of a friend, or a reminder of a place, or evidence of how you felt looking at a beautiful scene.

Next, ask yourself about the subject: What is this person like? What does this place mean to me? What makes this scene so beautiful? The answers will tell you the mood you want in your picture. You can use the techniques in this book to help you create that mood.

If you care about someone, for example, you will want to use light that will flatter that person. If you are outdoors, the time of day and quality of light can convey different moods. Select the red glow of sunset for romance, the cold gray of gloomy skies for melancholy, or a shaded setting with a shaft of sunlight for a bright, cheerful portrait.

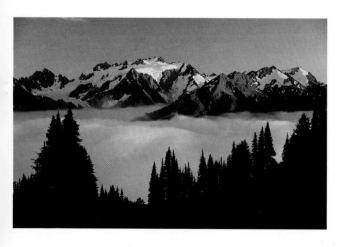

Good landscapes often require two or more visits to the site: First to find the right viewpoint, then to select the right time of day. To make this picture in Washington's Olympic National Park, the photographer sought a good vantage point by studying topographic maps. He found it eight miles along a trail—in the rain—and had to return days later to catch the soft, low light of late afternoon.

Seeing in Two Dimensions

Because we have two eyes that see from different angles, we perceive three dimensions — height, breadth, and depth. A photograph has just two dimensions; it shows depth only by perspective.

For this reason, a subject's size or grandeur may seem obvious to your eyes as you click the shutter, yet disappointing in the resulting picture. Your dramatic landscape looks flat and dull. Your giant tree trunk seems tiny.

You can solve these problems by training yourself to view the world as the camera does, in two dimensions. Since the camera has only one eye, the lens, study your subject with one eye closed. Hold up your hands to form a frame. Imagine the scene as if it were a picture printed in a book or hanging on your wall. Does it come alive? If not, try moving so that there is something in the foreground; this will usually add the feeling of depth or distance.

To convey size, whether large or small, add something or somebody to your composition to show scale. This principle applies when you're photographing any object whose proportions are not obvious, like this 120-ton ore hauler.

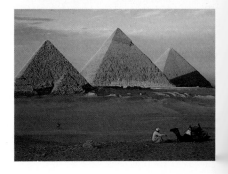

Suggest depth by including in your picture things of familiar size (people, cars, telephone poles, houses — even camels) at varying distances. Roads, fences, or railroad tracks that dwindle away also give the feeling of the missing third dimension.

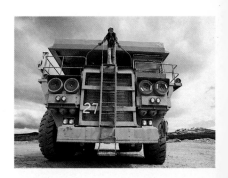

The Right Light

Photographers train themselves to think constantly about light—not only about its strength, but also about its direction, its source, and its color.

Light Direction

The angle of the lighting you use can emphasize texture or subordinate it; define form or destroy it; and impart a bright mood or a somber one. Light from above and behind the camera flattens

Of the various lighting angles, frontlighting provides the brightest colors but flattens out detail and may create glare. Thus the often-heard advice "keep the sun over your shoulder" may yield a good exposure, but not necessarily an interesting picture.

Sidelighting brings out shape and texture, and is perhaps the best angle for general use. When photographing landscapes, avoid high overhead light, such as at noon, because it wipes out detail. Reserve high sun for vertical surfaces, which are sidelighted at midday—walls or sheer mountainsides.

Backlighting creates bright highlights and separates foreground from background. Use backlighting in portraits, to create sparkle on water scenes, to de-emphasize a confusing background, and for any lively or dramatic effect.

out the scene, because such *frontlighting* creates no highlights or shadows. A better choice is to shoot with the sun or light source off to the side, shining down on the subject at an angle of about 45 degrees. This *sidelighting* brings out the most form and detail.

Backlighting adds drama. In portraits, it creates a pleasing halo through the hair. High-contrast backlighting makes silhouettes.

Hard or Soft: The Source

Hard lighting comes from a single point source, such as the sun, a spotlight, a flash, or a bare bulb. Its high contrast accents detail and texture. Use this kind of lighting to gain realism.

Soft lighting, from a diffused source, is found indoors with indirect lighting, and outdoors in open shade or on overcast days. It is best for portraits and cool, peaceful outdoor scenes.

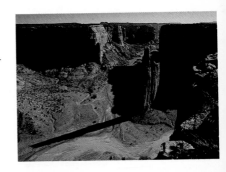

Hard lighting: Brilliant sunlight, particularly at midday, produces sharp-edged shadows and high contrast. Sunlit areas show bright colors, while shaded ones turn almost black. This combination of extreme light and dark can make strong compositions.

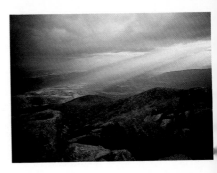

Soft lighting: On a cloudy evening, rays from a low sun break through, suffusing the scene with delicate hues that bring out the best in color film. Heavy overcast brings even softer lighting — shadowless and difficult to use for landscape pictures, but excellent for portraits.

● **Normally, your brain compensates for the color of light, so "white" looks white no matter what kind of lighting you are in. You can see how white varies from bluish to yellowish, though, if you note the appearance of a piece of typing paper under sunlight near a window, and then under a table lamp.**

Light Has Color

The color of light varies. An untrained eye doesn't see the subtle differences, but they register vividly on color film.

Daylight is bluer than the light from normal lightbulbs—*tungsten* light. For this reason, color slide film designed for daylight use turns objects red-orange under tungsten light or firelight. Indoor Type B tungsten film, designed for light bulbs, yields blue slides if used in daylight. Both films need a filter to correct the greenish cast of fluorescent lights.

Daylight color film is right for midday sunlight. But sunrise and sunset give a reddish cast, good for golden-glowing landscapes and romantic portraits. Overcast skies or early-morning mist give an image a moody bluish tint.

Train yourself to notice light. When you plan a picture, study not just the subject, but the pattern of highlights and shadows as well.

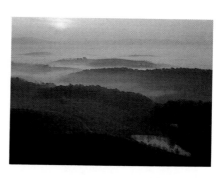

Early morning and late afternoon are the times for warm lighting. Then sunlight must take a longer path through the atmosphere than at noon, so it turns golden, bathing everything it strikes in a warm glow. When very low on the horizon, the sun can turn white surfaces bright red.

Cloudy weather and open shade produce cool lighting, slightly bluish. "Open shade" means shielded from the sun but lit by a large section of the blue sky, hence the coloring. Sunlight is at its "purest" white—not always its most interesting hue—between midmorning and midafternoon.

The Right Angle

Most people stand when they take photos, but this may not give the best or most exciting angle on the subject. You should explore other points of view.

The right height and angle depend on the situation. You've probably seen professional photographers crouching, climbing, leaning one way or another, or even lying on their bellies as they peer through the viewfinder. They may look funny, but they're dead serious in seeking the best angle.

A low angle can make people, trees, or buildings look taller, and it can eliminate clutter from the background by placing subjects against the sky.

If you take a side angle, across a line of people, cars, or trees, you can unify the picture by tightening the ranks.

Use a high-angle view—from a fence or tree, for instance—to eliminate gray skies on dark days, or to reveal patterns in landscapes or crowd scenes.

So before you shoot, walk around your subject with your eye to the viewfinder. Decide what angle will give you a clutter-free, expressive picture. Consider unusual angles: Our normal view of a giant statue is from its base, so try to find a high vantage point that will give you an unusual, eye-to-eye portrait.

● *Here's one way to get a novel, ten-foot-high viewpoint when there's nothing to climb on. Attach your camera to a fully extended lightweight tripod, set the controls, and trip the delayed-action timer. You'll have ten seconds or so to raise the tripod high overhead, holding it by the feet, and point the camera before the shutter clicks. Since your aim won't be accurate, it's best to make several exposures and use a wide-angle lens.*

A high, downward-looking camera angle and the raised hoof (left) suggest a steep trail. A low camera angle, on the other hand (right), emphasizes the height of the horse's leap.

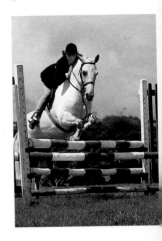

Closing In

Framing the picture in the viewfinder before you take it is just as important as framing the finished print. For sharp, crisp enlargements and striking compositions, use every bit of film for the picture. Don't waste any area.

If you could look at the entire "take" of a Geographic photographer, you would see that most exposures are complete pictures that need little cropping. Professionals fill the frame. That's one reason their pictures look so good.

To fill the viewfinder frame, edit before you shoot. Look at the scene and ask yourself: What can I eliminate? Get rid of the car bumper sticking into the corner of the frame, or the fence running through someone's ears. (When you're concentrating on your subject, it's easy to forget to inspect the background for clutter.) Beware as well of a "hot spot"— any extraneous patch of bright white or reflected sun glare; it will leap out of the finished picture.

You'll be surprised how much excess picture area you can subtract if you glance around the edges of the viewfinder to see what's really there. And if you're shooting rectangular-format film like 35mm, turn the camera vertically to see if the fit is snugger.

● *Failure to get close enough is one of the most common photographic mistakes, easy to make without realizing it. The next time you're photographing someone, take one picture at your normal distance, then walk a few feet closer and take another, then closer, and yet another. Compare the results and you'll see the difference.*

The portion of this picture outside the line is unnecessary. Closing in on the boats makes a more effective composition; turning the camera to the vertical would fit the frame to the shape of the sails.

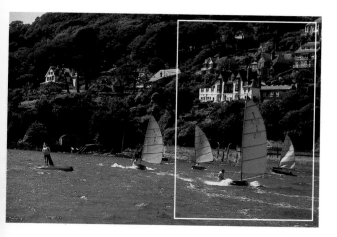

Composition

Centering your subject and snapping the shutter isn't composition. Sometimes a picture just falls together, but not often. To come up with an eye-stopper, you have to be extremely careful with your picture arrangement.

All pictures need a center of interest, a point that draws the eye's attention. In a landscape the center of interest might be a building, a mountain, a river, or a group of people. In a portrait it is usually the eyes. But where do you put your point of interest? Unless you want a static, symmetrical feeling, try to set up an off-balance composition that entertains the eye. One principle you can always start with is the rule of thirds.

Imagine lines that divide your picture into thirds vertically and horizontally. A good place for the center of interest is any point where these lines intersect. You can also balance a center of interest and a counterpoint at opposing intersections. Balance the composition so that both sides are pleasing but not of equal size, shape, or color. A small area of vivid color in one part of the picture will balance a larger area of less intense hue. A small person or animal will balance a large inanimate object.

Generally, don't run the horizon across the middle of the frame. It will look better a third of the way up or down—or out of the picture altogether.

Always check for background clutter,

● *Reflections can add interest to your compositions. Try using mirrors, still water, windowpanes, even doorknobs. But be careful. In other situations the same surfaces may create distracting glare. Watch out too for unwanted reflections from eyeglasses, picture glass, paneling, appliance fronts, or metal surfaces.*

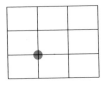

Rule of thirds: Put your center of interest—the whale—where lines one-third of the way in from the picture's edge intersect (above).

12

which distracts the eye from your center of interest. Eliminate unwanted objects by changing your camera angle or moving your subject. With an adjustable camera you can throw the background out of focus, or isolate your subject from the surroundings by backlighting.

Triangular patterns are good for group portraits. They concentrate attention and keep the eye in the photograph.

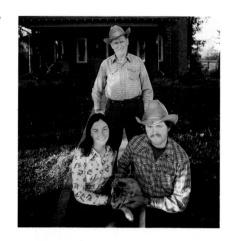

To suggest energy and action, choose diagonals. A diagonal anchored to the edges of the frame—unlike this boat—takes on the rigidity of a triangle, lending a sense of strength. Such diagonals make forceful architectural pictures.

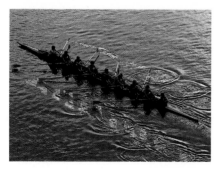

An S curve, sometimes called Hogarth's line of beauty, signals grace, youthful energy, or flowing movement.

Patterns form strong compositions. Here, repetition of the same basic shapes creates rhythm and suggests the strong common identity of the cadets.

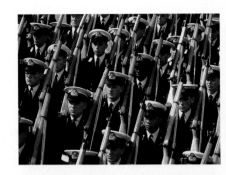

A small spot of vivid color creates a center of interest, if backed with large areas of duller tones. A patch of white will work the same way.

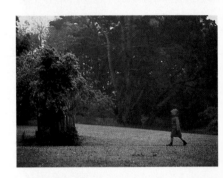

Framing your subject with branches, arch-ways, or fence railings calls attention to it. Don't be afraid to let the frame occupy most of the picture at times.

Leading lines take the eye into the picture and often add depth. Most subjects contain strong lines, some as obvious as a stripe on a highway, others as insubstantial as a shaft of light or a fold in a scarf. Look for these lines and use them.

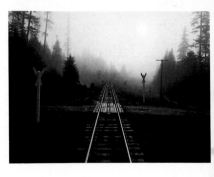

Horizontal lines convey tranquillity. The monochromatic effect of a golden green moor, backlighted by the evening sun, reinforces the peaceful feeling. A color that did not harmonize would have spoiled the mood.

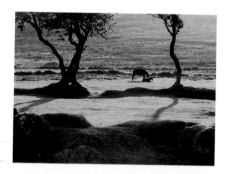

When the lines of your subject lead your eye vertically, shoot that way. Vertical lines can create a sense of power and excitement. Here the interplay of diagonals adds movement.

Use heavier verticals—tree trunks or pillars, for instance—to lend an aura of dignity and majesty.

● **Don't get stuck in "horizontal hold." Every time you're about to make a picture with 35mm or 110 film, ask yourself how it would look as a vertical. Scenery often looks best in horizontals, but a portrait or any subject taller than it is wide may call for a vertical.**

When you position moving figures, put more space in front of the action than behind it, so that the subjects don't look as if they're leaving the picture.

A fence, a road, even a shadow can lead the eye to the main point of interest. A badly positioned strong line will take the eye off to the edge of the picture and shatter the composition.

Try these basic rules. When you get bored, break them. No rule is so rigid it can't be ignored. Again and again photographers advise: Experiment. Many professionals are happy to get one good picture from a whole roll of film.

15

Mastering Your Camera

A light-tight box, a lens, a shutter, a viewfinder, a place for film: Stripped to basics, that's what a camera is. Learn to work the basics first, and your skills will rest on a solid foundation.

Cameras

Cameras are made in many styles and sizes. Most popular are the compacts, which take disc or 35mm film, and the 35mm SLR models (35mm is the film width; SLR means single-lens reflex).

● **Whatever camera you select, study the instruction manual. You cannot learn how to operate your specific model from a general-purpose handbook such as this one. If your manual is lost, write to the manufacturer for a new one.**

Point-and-Shoot Cameras

For lightness and convenience the compacts can't be beat. Most have automatic controls, but limited exposure range.

Simplest are the disc cameras and 35mm fixed-focus models. They are designed for point-and-shoot snapshots—convenient recorders for the family album. Like the 110 cartridge camera that preceded it, the disc camera produces small negatives, but good enough for album-size enlargements.

The 35mm cameras produce larger negatives, so you can get bigger enlargements without losing sharpness. The more expensive 35mm compacts offer automatic film advance, built-in electronic flashes, exposure control, autofocus, and zoom lenses.

Compact cameras fit the pockets of snap-shooters—and of off-duty pros who like to keep a camera handy. Many of these cameras use fixed-focus lenses that don't work on subjects closer than a few feet away.

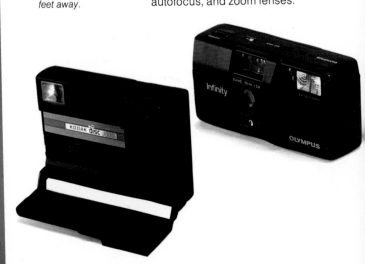

- *You can do only so much with a point-and-shoot camera. If you are serious about photography, you should plan to get a more sophisticated model. Even if you own only a compact camera, you will find much of this handbook useful, but for many techniques described here you do need a 35mm SLR.*

Angular housing atop a typical 35mm SLR (below) hides a penta-prism that erects the image as it passes from lens to mirror to eye (above). When the shutter snaps, the mirror flips up, and the image strikes the film.

The 35mm SLR

For usefulness in almost any situation, few cameras come even close to the 35mm SLR. Thus it has long been a favorite of amateurs and pros, including the majority of National Geographic field photographers.

The 35mm SLR has two big advantages. It accepts many lenses, and it lets you view right through the lens.

The variety of lenses it can use helps control the picture. You can move in so close that the image on the film is the same size as the subject (a technique called photomacrography), or stand far from your subject and still fill the frame.

No matter what lens you use — normal, wide-angle, telephoto, close-up, or zoom — the SLR's ingenious mirror and prism system shows you what the film will see. On some models a little of the image may be lost at the viewfinder's edges. A flagpole you think is just out of the picture may prove to be just in.

New SLRs incorporate sophisticated electronic automatic exposure systems. Some also provide autofocus: The camera can automatically focus on a spot at the center of the picture. Be sure to read your camera manual; autofocus doesn't work in every situation.

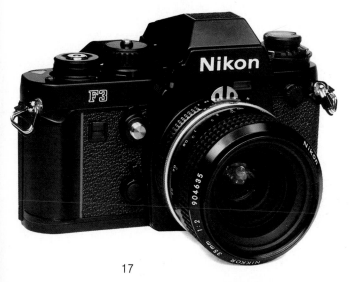

Other Cameras

There are many other models, such as the 35mm rangefinder, mid-size SLR, view camera, and instant-print camera.

The rangefinder lacks the versatility and through-the-lens viewing of the SLR. But it's simpler, lighter, and usually less costly. It is also much quieter; many pros prefer a 35mm rangefinder for candids, theater scenes, and other situations in which they need to remain unobtrusive.

Medium-size SLRs cost more than 35mms, but the larger film yields better enlargements. Professionals like them for fashion, portraits, and landscapes.

The instant-print cameras, made by Polaroid, let you enjoy or give away a print on the spot, or try again if the first shot did not come out well. But the small prints are costly, since they include processing. There is no negative; enlargements are made by copying a print.

Other cameras may fill your needs. The bulky view camera (upper right) is fine for architectural and studio work; it corrects distortion and its enlargements are superb. But it bows to the 35mm rangefinder (lower right) for action and candids. A good compromise: the mid-size SLR (upper left). All three make you wait; the instant-print (lower left) hands you a picture in seconds.

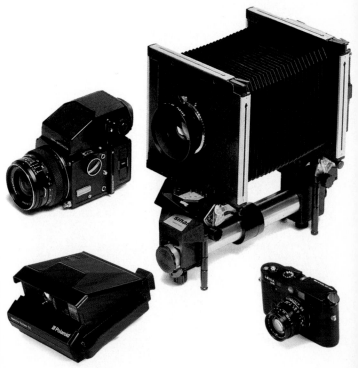

Loading Your Camera

● *Yes, you can change film mid-roll. Note the frame number, then rewind slowly just until you feel the leader pull free from the take-up spool. Open the camera and mark the cassette with the frame number. When reloading the cassette, put the lens cap on, then advance the film two frames past the number you noted. If you goof and rewind the leader into the cassette, there's a cheap retriever you can buy to fish it out.*

Load film indoors or in shade; direct sun can leak into the cassette. The emulsion (the film's dull side) must face the lens. Advance until both rows of holes engage sprocket teeth, then close the back.

Loading the 110 and disc cameras is virtually foolproof. But there are some tricks to the 35mms. Basically, you must drop the cassette into its chamber, secure the leader strip to the take-up spool, and engage the sprocket teeth in the film holes. Check your camera's instruction manual for specifics.

When you have loaded the 35mm film and closed the camera, do not assume that all is well. Gently turn the rewind knob or crank clockwise until you feel the film pull snug; if it rewinds freely, you know it has come loose from the take-up spool and must be re-engaged. Snugging the film tight also ensures that it lies flat as it goes through the camera.

As you advance the film to the first frame, watch to see that the rewind knob turns; this shows the film is being drawn out of its cassette. If the frame counter is not advancing, open the camera back and make sure the film hasn't torn or slipped off the sprocket teeth.

Set the film speed—the ISO number—on your light meter *before* you load the film. That way you won't shoot the whole roll at the wrong speed.

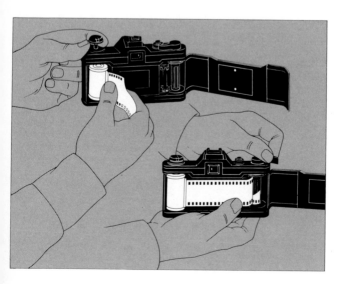

Holding Your Camera

It seems so simple to hold a camera steady that most amateurs think it comes naturally. Yet camera movement accounts for the vast majority of spoiled pictures.

The best way to hold a camera comfortably but rigidly is to form an imaginary tripod with the camera pressed against your forehead and your elbows steadied against your body. Take a breath, exhale partway, and gently squeeze the shutter button. Practice this technique with an empty camera until you feel rock-steady.

To avoid camera movement when you release the shutter, remember that most shutter buttons can be depressed two-thirds of the way before they actually click. Learn where your shutter's release point is and depress the button to that point when you're about to shoot. That way you need only a tiny additional pressure to take the picture.

● *If you keep your neckstrap very short, a turn of the strap around your hand will tighten it against the back of your neck to steady your camera. Brace your head against a wall or tree for long exposures.*

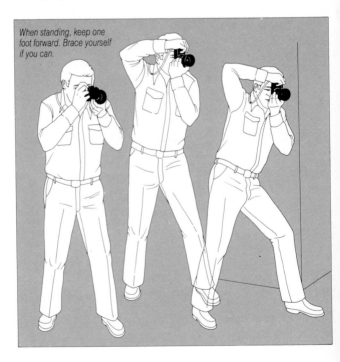

When standing, keep one foot forward. Brace yourself if you can.

Choosing Your Film

One advantage of shooting 35mm slides, even if you prefer color prints: Slides may cost less. You can experiment and then print only the best of each roll.

If you do shoot color or print film, you may save by ordering a black and white contact sheet instead of a full set of color prints. Then use a magnifying glass to choose the frames you want printed.

The higher the ISO number, the more sensitive the film. You should find this series of ISO numbers available for setting your camera's light meter:

25	32	40
50	64	80
100	125	160
200	250	320
400	500	640
800	1000	1200

It's an even progression; ISO 100 is twice as sensitive as ISO 50, and half as sensitive as ISO 200. Thus, if you double or halve the ISO by switching films, it's the same as changing the exposures you can use, by one shutter speed or lens aperture setting.

Film comes in a variety of speeds. A film's *speed* is a measure of how sensitive it is to light. Film speed is rated on the ISO (International Standards Organization) scale, which ranges from ISO 8 to ISO 6400 or higher. The higher the ISO number, the more sensitive, or *faster,* the film and, usually, the grainier the image it produces.

ISO numbers incorporate the ASA scale previously used in America. ISO 100/21° means a speed of ASA 100 (or 21° on Europe's old DIN scale). Be sure your film also has a "DX" on it if you use an automatic camera; DX encoding lets the camera read the ISO off the film can.

The ISO number helps you choose the right film. A slow film with a low ISO number, such as Kodachrome 25, has extremely fine grain and excellent clarity and tonal contrast. A fast film, such as Fujichrome 400, is grainier and less sharp, but you can use it in dimmer light, or with a faster shutter speed or a smaller lens opening.

Since the quality of the image goes down as the ISO number goes up, a good rule is to choose the slowest film you can use for the lighting conditions in which you plan to shoot. Choose fast film only when you need the speed. Or compromise on a medium speed, from ISO 64 to ISO 100, for convenience if sharpness is not crucial.

To find the film that best suits your technique, try them all. Choose the one you find most suitable and use it exclusively until you become completely familiar with its characteristics. Deviate from it only when you need to. Charts on pages 22 and 24 offer guidelines.

Color slide film comes in various *emulsions,* or light-sensitive coatings. The daylight type is balanced for sunlight; it renders colors correctly when used outdoors by day, or with electronic flash or blue flashbulbs. Tungsten film,

Daylight color slide film sees red when shot indoors under ordinary tungsten light bulbs (near right). Colors improve with Type B film (far right), balanced for such reddish light. But in the bluer light of day, Type B sees the world in mood indigo (lower)— ruinous to most pictures, but useful when done deliberately for effect in landscapes.

Color print film has a higher tolerance for varying colors of light. It yields a negative, not a finished picture as slide film does. Colors can be corrected during printing. But for best prints under tungsten light, use an 80A filter on your lens.

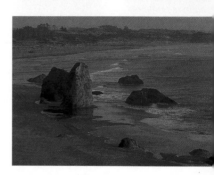

Commonly Used Color Films

Film and ISO	Size	Characteristics
Kodachrome 25 Fujichrome 50	35mm slides 35mm, 120 slides	Slow speed, extremely fine grain; good for sharp enlargements and large-screen projection
Kodak Ektachrome 64	35mm, 110, 120, 126 slides	Medium speed, very fine grain; may be processed at home
Kodachrome 64	35mm slides	Medium speed, extremely fine grain; requires Kodak processing
Kodacolor Gold (ISO 100) Fujicolor 100 Fujichrome 100	35mm, 120 prints 35mm, 110, 120 prints 35mm, 120 slides	Medium speed, very fine grain
Kodak Ektachrome 160	35mm slides	High-speed tungsten film, medium grain; for artificial lighting
Kodacolor Gold (ISO 200) Fujicolor 200 Kodak Ektachrome 200 Kodachrome 200	35mm, 110, 126, disc prints 35mm prints 35mm, 120 slides 35mm slides	High speed, medium grain
Kodacolor Gold (ISO 400) Fujicolor 400 Kodak Ektachrome 400 Fujichrome 400	35mm, 110, 120 prints 35mm, 120 prints 35mm, 120 slides 35mm, 120 slides	Very high speed, medium grain
Kodacolor VR 1000 Fujicolor 1600 Fujichrome 1600	35mm prints 35mm prints 35mm slides	Ultra-high speed films, medium-coarse to coarse grain

In bright light, slightly underexposing color slide film may make colors look richer by increasing color "saturation." The easiest way to do this is to set the camera's light meter one notch higher than the ISO of the film—for example, set Kodachrome 64 film at 80. (This does not work with color print film.)

When a negative is printed, it is usually enlarged; when a slide is projected, the image may be hundreds of times its size on the film. That's when you notice "grain," the pebbly mottling of light-sensitive particles in the film's emulsion. Larger particles mean a faster film—and a grainier, lower-contrast image, as in the lower enlargement of the eyes shot on ISO 400 film. But the portrait on slower ISO 64 yields a blowup (upper) that is sharp and nearly grainless.

or Type B, compensates for the redder light of incandescent lighting. Photolamp, or Type A, is for studio lighting. You can use a film in the wrong light if you correct with a filter, but a film does best in the light it's designed for.

Some films can be developed in a way that compensates for underexposure; this is called *pushing*. It lets you shoot in low light as if the film had a higher ISO speed. The film then needs special handling, which many processing labs offer at extra cost.

To push your film, set your light meter at double the ISO rating of the film and, if you need still more speed, double it again. Shoot the entire roll at that same ISO rating, and mark the container with the new ISO number. Since the strip of film is processed as a unit, you cannot start pushing at mid-roll without sacrificing frames already shot.

Pushing makes film grainier and may throw the colors off. Doubling the ISO speed is hardly noticeable, but beyond this, experiment first to see how much grain you can accept. Don't push film if you can buy it in a higher ISO. Kodak Ektachrome 400, for example, may yield better results than Ektachrome 200 pushed, and will cost less to develop.

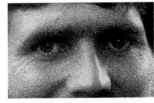
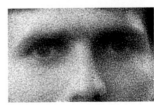

Black and White Films

Photography was born in black and white and grew up virtually color-blind. Many amateurs and professionals still prefer black and white photography. Try it; it will teach you to see forms, lines, patterns, and textures. It will sharpen your awareness of the elements of composition. And because it renders colors in tonal gradations—whites, grays, and blacks—it may improve your "color eye" as well. It may even spark an interest in darkroom work.

Black and white films come in a wide variety of speeds, plus various special-purpose emulsions. Kodak Panatomic-X (ISO 32) and other slow films offer excellent tonal rendition and extremely fine grain. Kodak Tri-X Pan, rated at ISO 400, produces an image with more grain, but it functions in about a twelfth as much light. Some black and white films can be pushed.

● *Look around you. Now squint hard and look again. Details vanish, colors fade; shapes and light intensities take over. Photographers often "preview" a scene by squinting to see how it will look in black and white.*

Type of Film	ISO	Size	Characteristics
Kodak Panatomic-X	32	35mm, 120	Slow speed, extremely fine grain, capable of very sharp enlargements
Ilford Pan F	50	35mm, 120	
Kodak T-Max	100	35mm, 120	Medium speed, fine grain, capable of sharp enlargements
Agfapan 100	100	35mm, 120	Medium speed, medium-fine grain, long tonal range (that is, a wide variety of gray tones)
Kodak Plus-X Pan	125	35mm, 120	
Ilford FP4	125	35mm, 120	
Kodak Verichrome Pan	125	110, 120	Medium speed, medium-fine grain, wide exposure latitude
Kodak Tri-X Pan	400	35mm, 110, 120	Very high speed, medium-coarse grain, wide exposure latitude
Agfapan 400	400	35mm, 120	
Ilford HP5 400	400	35mm	
Fuji Neopan 400	400	35mm	Very high speed, fine grain, capable of sharp enlargements
Kodak T-Max	400	35mm, 120	
Ilford XP1 400	400	35mm, 120	Film based on dye rather than silver; medium grain.

Commonly Used Black and White Films

Texture takes over as black and white film strips the color from a weathered beam. In photographs without colors, other visual elements dominate— among them the patterns in surfaces rough and smooth.

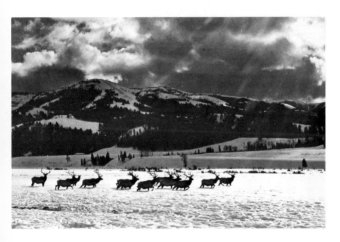

Velvety blacks, snowy whites, a full range of grays—that's the recipe for black and white at its best. Here backlighting (above) gives the print its black in shadowed hills and herd, its white in sunlit clouds and snow.

Black and white can be just that, with almost no gray. Silhouettes require extreme lighting contrast between subject and background. Expose for the bright background.

Exposure

Exposure, the amount of light that hits the film, depends on two controls: the size of the lens opening, called the *aperture,* and the length of time light pours through the opening, controlled by *shutter speed.* On some cameras these controls are fixed. On others they're automatic. But on many you adjust aperture and shutter speed yourself.

f-Stops

F-numbers are usually engraved on the lens barrel. They show aperture size, which is controlled by a diaphragm of overlapping plates. Each setting is called an *f-stop.*

If you *stop down* or close the lens opening from one f-stop to the next higher number, you cut in half the amount of light admitted. Open up one f-stop and you double the light. Thus f4 admits half as much light as f2.8, twice as much as f5.6, and four times as much as f8.

F-numbers can be confusing unless you remember that the smaller the number the bigger the aperture, and the more light admitted to the film. So think of the f-number as the bottom of a fraction (actually the ratio of the aperture to the focal length of the lens): f4 ($\frac{1}{4}$) must, therefore, be bigger than f16 ($\frac{1}{16}$).

The advantage of this system is that the proportions are the same no matter what lens you are using — f4 lets in exactly as much light on a 200mm lens as it does on a 50mm or any other lens.

F-stops also control how much of the picture will be in sharp focus. More about focus on page 32.

Shutters

A shutter is a system of moving curtains or overlapping metal leaves that forms the door to the camera's light-tight box. The faster the shutter speed, the smaller the amount of light that gets in. On the camera, the speeds are usually marked

f2

f2.8

f4

f5.6

f8

f11

f16

Don't let terms such as "fast" and "speed" throw you. They apply to lenses, films, and shutter speeds—all three. In dim light you would use a fast lens (one that can open to a very wide aperture to let in lots of light), a fast film (one that's very sensitive to light)—but a slow shutter speed (one that allows a lot of time for the light to strike the film).

with a series of numbers such as 1000, 500, 250, 125, 60, 30, 15, 8, 4, 2, 1, and B. These are fractions of a second; 60 means one-sixtieth of a second (1, of course, means one full second). As with the f-stops, a change of one setting either doubles or halves the exposure.

The B setting is used for time exposures. The shutter stays open as long as you hold down the shutter button.

At shutter speeds slower than $1/30$ with a normal lens, you can't hold the camera steady enough to get sharp, clear pictures. Brace it on a solid surface or use a tripod. A fast shutter speed, on the other hand, stops camera movement as well as subject movement. For sharp photos from a moving car, train, or plane, shoot at $1/500$ or $1/1000$. To avoid vibration, don't brace the camera against the vehicle.

Lens or Shutter—Which to Set First?

Since shutter speeds control motion, and f-stops control depth of focus, you must decide which setting is more important for the picture you want to take. (More of this on pp 32 to 37.) Once you

Think of the link between shutter speeds and f-stops as a pair of triangles (upper). Each partition of a triangle stands for the amount of light admitted. Together the triangles equal exposure. If your meter reads f2 at $1/500$ (yellow bar), you could choose f5.6 at $1/60$ or any other vertical pair, yet get the same exposure. If your meter says you need more exposure—f2 at $1/30$—the triangles realign (lower), showing other settings that will also let in the same amount of light.

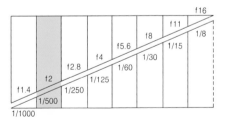

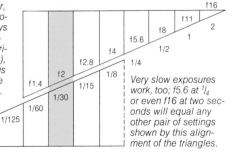

Very slow exposures work, too; f5.6 at $1/4$ or even f16 at two seconds will equal any other pair of settings shown by this alignment of the triangles.

● *A simple device helps you see what exposure settings are available as you shoot. Cut two cardboard disks of unequal size; pin their centers together so they turn like wheels. Around the edge of the outer disk draw evenly spaced marks, labeled with the f-stops on your lens. Next to them on the inner disk, write your camera's shutter speeds, increasing in the opposite direction. Now meter a scene. Line up the disks to show the settings your meter calls for. Any other pair of settings shown will also expose that scene correctly.*

have picked one setting, your camera's light meter will dictate the other.

On manually operated cameras, you adjust both shutter speed and lens opening yourself. With most automatic cameras, you set one control (called the priority control) and the camera makes the other setting automatically. Some cameras have both aperture-priority and shutter-priority systems.

Often you don't have to worry about choosing between f-stop and shutter speed. For general purposes, just keep your shutter at $1/125$ and change the f-stop to adjust the exposure.

But keep in mind that the shutter dial on the camera and the f-stop ring on the lens work the same way: Each change in setting either halves or doubles the exposure. Whenever you stop down one f-stop from the correct exposure, you must compensate by going to the next slower shutter speed, so the exposure remains the same. And for every increase in aperture size, you must use a faster shutter speed. In this way you can select among a range of combinations, all yielding the same exposure.

The Right Exposure

Exposure was once a big problem in photography, but today most cameras have a built-in exposure meter that measures the light automatically. In simple cameras the exposure controls are

This scene reflects about 18 percent of the light falling on it, which is average. Meters assume this average, so a reading here gives the right exposure. If boat and beach were white, reflectivity would soar—yet the meter would read them as an average scene now in brighter light. Result: underexposure.

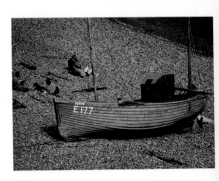

Meter cheater: a white swan on dark water. Here your light meter reads the expanse of dark water and gives settings that put detail in the water while over-exposing the swan, as at right. To expose the swan properly, stop down the aper-ture or speed up the shutter by one or two steps and let the water go dark (lower).

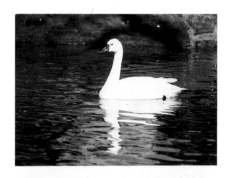

Most light meters average the light from the entire field of view, though some—called "center-weighted"— give more emphasis to the light at the center of the frame. Even with these, if your main subject is lighter or darker than average, you must second-guess the meter.

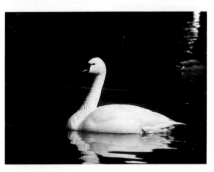

Another meter cheater: a dark subject against a light background. It will lose its details in underexposure (up-per). Increasing the exposure corrects the problem (lower).

The safest way to measure exposure is by metering some-thing that you know reflects an average amount of light, such as a medium shade of gray. Many pho-tographers carry an "18-percent gray" card and base expo-sures on readings from it. The inside back cover of this Field Guide is also an 18-percent gray card, together with instruc-tions for its use.

29

● *Never point a camera with a built-in meter directly at a strong light source. Too much light pouring into its sensors can damage them. Anytime a meter needle is as far as it can go at the overexposure end of its scale, it's in danger of damage. Aim away, cover the lens, or bring the needle down by stopping down the lens or increasing the shutter speed.*

fixed at settings correct for medium-speed film and a sun-over-the-shoulder average snapshot. More sophisticated cameras set their own controls. But you still must think for the camera and adjust for special situations.

Exposure meters are balanced for a typical scene on a sunny day. But when you take other kinds of pictures—a shadowed face against a bright background, for example, or a sunlit face against shade—the meter still "assumes" it is reading an average scene. You may get a correctly exposed background but a subject that is too dark (underexposed) or too light (overexposed).

One way to get a correct reading under these circumstances is to move in close and take the exposure reading directly from the subject. Then move back and shoot with the close-up exposure reading, regardless of what the meter now says. Another old standby is to take

Don't Trust Your Meter In . . .

Night scenes	The more dark areas there are between the lights, the more your meter will overexpose the scene. If you want detail in dark areas, move in close and take a reading off one of them. If you want just the pattern of lights, meter the whole scene and reduce exposure by one or two settings.
Snow, beach, or open water scenes	Meters reduce bright subjects to average by underexposing them. A white cat in a white chair presents the same problem. Increase exposure by one or two settings.
Dark-on-dark scenes	For a black cat in a black chair decrease exposure by one step—enough to deepen the blacks without losing detail.
Fog, rain, or drizzle	These conditions turn daylight bluish, and meters tend to overreact slightly to blue light. To correct for underexposure, increase by one setting. Or shoot one frame corrected, another uncorrected, to test your meter's error.
Scenes with dark-skinned people	Except in close-ups, dark faces will be underexposed against an average background. Correct by increasing exposure by one setting. Or you can move in, meter one face, back off again, and shoot at that setting.
Backlighted and sidelighted scenes	See photos opposite. In close-ups, you can lighten shadows with anything large and white—a sail, a piece of paper, even a person in a light shirt just out of the picture. More on reflectors for fill-in on page 92.
Scenes with high contrast between subject and background	See photos on previous page. Reduce by one setting to keep light subjects from overexposing, or increase by one to keep dark subjects from underexposing.
Dim light	A meter may lose accuracy at the low end of its scale. Take a reading from something white—a sheet of paper, a tablecloth—and reduce that exposure by two to three settings.

Failed meter? Just go on shooting, by using the guidelines in the data sheet that came with the film. Or follow the f16 rule:

At f16, in bright sunlight, use the shutter speed closest to the ISO of your film. If the ISO is 100, the nearest shutter speed is $^{1}/_{125}$. If the ISO is 400, shoot at $^{1}/_{500}$ at f16, or any other setting that gives the same exposure. Close down one stop on bright sand or snow. Open up one stop on hazy days, two stops on cloudy days, and three stops under heavy overcast or in open shade.

A backlighted subject (below)—one that's in shadow with the sun behind—can fool the meter; open up two stops more than the reading for the entire scene. For sidelighted subjects (right), open up one stop so detail in the shadows will register on the film.

a reading from a medium-tone gray card or from the palm of your hand. Be sure to hold the card or your hand at the same angle to the light as the subject.

Even if you expose color print film properly, you may still get somewhat muddy-looking prints of snow scenes or bright sandy beaches. That's because most processing is done by automatic printers adjusted for an average balance of light and dark. If a scene is lighter than average, the machine will darken it, turning your bright, white snow to gray. The only solution is to ask for hand processing. Pick only your best negatives, since this costs more.

Bracketing

When you want to make sure you get the exposure right, the answer is *bracketing*. To bracket, use the indicated exposure, then make additional exposures both under and over, for insurance. You can vary the f-stops in half-stop or one-stop increments, or use the same f-stop and vary the shutter speeds. You should bracket in any tricky lighting situation.

Pros make it a habit to bracket. They know there are variations in shutter speeds, f-stops, and even ISO ratings and processing.

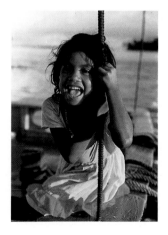

Focus and f-Stops

Most often, you'll focus with the viewfinder. In some cameras this involves matching up a split image; in others a small circle of microprisms shimmers until the lens is focused on whatever is in the circle. Some cameras focus automatically, but if you want an off-center composition, you must center the subject, lock the focus, and then reframe.

F-stops control *depth of field,* which refers to how much of the picture, from near to far, is in sharp focus. The smaller the aperture, the deeper the depth of field; the larger the aperture, the shallower the depth of field.

Depth of field also depends on two other factors: your lens and your distance from the subject. A telephoto lens has very little depth of field; a wide-angle, on the other hand, offers a generous range of sharpness. And with any lens, the closer you are to your subject, the shallower the depth of field.

You can use this knowledge to make a photo sharp throughout or to soften a background or foreground.

On most 35mm camera lenses a distance scale, marked in feet and meters, aligns with a depth-of-field scale, marked in f-stops, to show what will be in focus at various f-stop settings. Focus on your subject and choose an f-stop — f8, for example. Now look at the scales and read off the depth of field. Everything on the distance scale between the two marks labeled f8 will be sharp, and everything outside those marks will be out of focus. (On some lenses these f-stop marks are color coded, rather than labeled with numbers.)

To put as much as possible in focus, adjust your exposure for your smallest f-stop — often it's f16 — and set the infinity symbol (∞) on the distance scale opposite one of the two f16 marks on the lens barrel. Then look at the distance number opposite the other f16 mark.

● *When all else is equal, use an f-stop in the middle range of your lens. The optics perform best at medium f-stops.*

● *For medium-distance work — street scenes, outdoor activities, groups of people — you won't need to worry about distance scales if you use a medium-to-small lens opening. Simply focus about a third of the way into the group or scene. If you were facing ten rows of seated people, for example, you would focus on the third row.*

Focus, Depth of Field

Three shots with an 85mm lens show how depth of field changes. Here the lens is wide open at f2, and focused on the girl 15 feet away, as shown by a red mark on the lens (diagram). F-stop numbers beside this mark form the depth-of-field scale. Two f2 marks show what the photo confirms: Only objects 15 feet away, give or take a foot or two (zone shown in yellow), are in sharp focus.

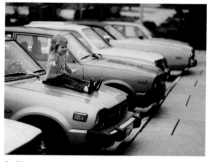

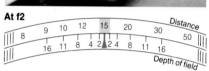

Away she goes. The photographer has not changed the f2 setting, so the depth of field is still shallow. But with the lens focused now at 40 feet, the f2 marks span a range from about 36 to 48 feet. Again the proof is in the picture; everything between 36 and 48 feet from the camera is in sharp focus. The child's first perch—the car 15 feet away—is now out of focus. The depth-of-field scale shows it would not be sharp even at f16.

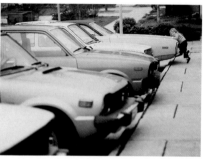

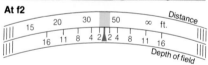

Back she comes, bringing the point of focus with her. This time the photographer stops down the aperture to f16 for a far deeper zone of sharpness. The lens is focused on the girl 30 feet away, but the two f16 marks show that she will stay in focus even if she romps as close to the camera as 14 feet or as far away as about 100 feet.

Lens models vary. Use the scale on your lens; these are just examples.

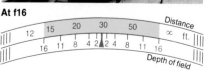

● *Selective focus is an excellent way to isolate your subject from confusing surroundings. Open to a wide f-stop, and you can focus crisply on a single person in a crowd or on a busy street, leaving the rest of the scene pleasingly blurred. Similarly, you call attention to a wild animal in a forest by throwing the distracting light-and-shadow background out of focus. In any generally blurry picture the eye immediately goes to whatever small part is in sharp focus.*

Everything in your finder from that distance to infinity will be in focus.

When you use this *universal focus* technique with an SLR, the finder will not show everything to be sharp, since the aperture stays wide open until the moment of exposure. Many SLR cameras have a built-in preview button or lever, which allows you to see in the viewfinder the actual depth of field at the f-stop you have chosen.

In many cases you may not want everything sharp. You can draw attention to your subject by blurring the rest of the scene, a technique called *selective focus*. If you want to throw an annoying background out of focus, open up to a wide f-stop. A good rule of thumb is to use a setting two or three stops down from wide open—on an f2 lens, for instance, shoot at f5.6. A telephoto lens, with its shallow depth of field, is excellent for selective-focus pictures.

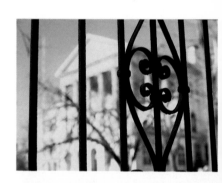

Shallow depth of field draws attention to a sharp foreground fence. The soft focus on the building beyond leaves the strong lines of the metalwork uncluttered, while still giving a sense of the fence's location.

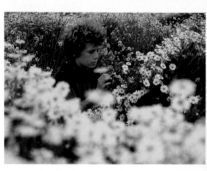

With the same technique you can blur a foreground to enhance a more distant subject. Here flowers fuse into a mist of color to create a mood and direct the eye to the boy and blooms beyond.

Motion and Shutter Speeds

Anticipate changes in light if you are waiting for something to happen. A splash, a crashing wave, a skier throwing up a spray of snow — in such cases the sudden burst of white will change the exposure by a stop or two from the reading you took before the action occurred.

You can interpret action in two basic ways: by stopping the motion or by blurring the image to show movement. The choice will depend on the subject and the visual effect you want to create.

Whichever method you choose, remember that fast-moving situations may not allow you time to focus and re-focus. While you're trying to keep the picture sharp, you'll be missing out on the action. So start by picking a relatively small aperture, then set the focus so that the depth-of-field scale on the lens covers the range where the action is most likely to occur.

Freezing the Action

To freeze motion, you will need a fast shutter speed, unless you're using electronic flash. Use the fastest shutter speed you can without opening the lens so far that you lose the depth of field you need. If you have to open up too much,

A shutter speed of ¹/₁₀₀₀ halts a baseball on its way to the bat. Though motion is frozen, action is implied. A diver caught between the board and water, a football player in midair, or a cheerleader at the height of her leap all imply action because the subjects couldn't hold such poses and therefore must be in motion.

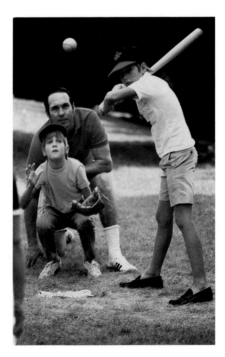

To stop action 25 feet from your camera with a 50mm lens, try these shutter speeds, or faster. If you *double* the distance between you and the subject, you may safely *slow* the shutter by one speed. If you cut the distance in half, go to the next faster speed, and so on.

If you switch to a 100mm lens (twice the normal length), *double* these speeds. For a 28mm wide-angle, *halve* the speeds. And so on.

MPH	Motion	Direction of motion		
		↔	⤬	↕
5	Walking, handwork	$1/250$	$1/125$	$1/60$
10	Jogging, children playing, horses walking, slow vehicles	$1/500$	$1/250$	$1/125$
20-30	Fast dancing, sports, city traffic, horses trotting	$1/1000$	$1/500$	$1/250$
40-60	Open highway traffic, racehorses, speedboats	$1/2000$	$1/1000$	$1/500$

then change to a faster film or get more light on the subject.

Still stymied? Consider moving to another vantage point. As the arrows in the table above suggest, you need the fastest stop-action shutter speed for movement directly across your field of view. But you can safely use a slower shutter speed if the same action passes at an angle to the camera, and slower still for movement toward or away from you.

Slower shutter speeds than those in the table will probably give you a blur — an effect you may prefer.

For stopping very fast action, use an electronic flash. Set your shutter at the flash synchronization speed listed in your camera manual (usually $1/60$ or $1/125$), and then forget about shutters. The flash

Swirling skirts blur into blossoms of color when photographed at a slow shutter speed. Any slower, and the dancers' legs and faces would have blurred; any faster, and the action might have been frozen. To be safe, shoot at several shutter speeds.

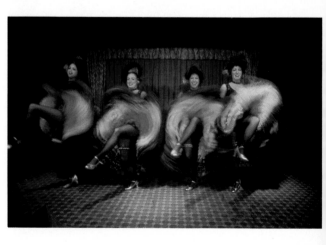

pulse itself, often lasting much less than $\frac{1}{1000}$ of a second, stops the action. (For more on flash, see p 50.)

Blurring the Movement

Deliberate blurring often conveys motion better than freezing it. After all, a stop-action picture of a speeding race car looks no different from a race car parked on the track.

You can blur movement in several ways. Using a slow shutter speed, hold the camera steady and let the action blur against a sharp background; or pan with the action so the subject is relatively sharp against a blurred background. (Some photographers try a third way; they purposely shake the camera at a slow shutter speed, so as to blur the entire picture.) You can only guess at the results, but that's part of the fun of shooting blurred action. So take several shots at various shutter speeds.

To pan, first focus on the point where your subject will be when you shoot. Then, in a smooth motion, track the approaching subject, press the shutter button as it reaches that point, and follow through without hesitation. For an impressive blur, try panning at a very slow shutter speed of $\frac{1}{8}$ of a second.

When you watch action, you pan with your eyes. Do the same with your camera's "eye." Aim the lens at the subject and turn to keep it in the viewfinder. A slow shutter speed will then blur the background and sometimes part of the subject, as with the horses' hooves below.

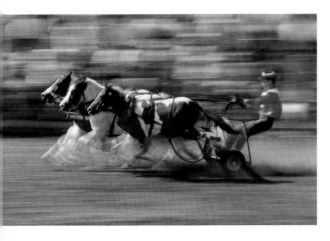

After the Basics

Photographic accessories can unleash your creativity, but beware of becoming preoccupied with equipment at the expense of the picture. Avoid changing lenses when you can simply walk closer or back off. You may miss the action if you're busy toying with lenses or filters.

Lenses

● *One rule of thumb for building your lens collection is to go roughly in multiples of two: If you start with a 50mm, you might buy a 105mm telephoto next, and then a 28mm wide-angle. The next step might be a 250mm telephoto, and finally a 15mm fisheye. Another good set would be 17-35-85-200mm.*

● *Slow lenses are cheaper than fast ones. An f2 lens will cost less than an f1.4. Another way to save, especially on expensive models, is to look for a used lens. Often you can try one out before buying.*

Normal Lenses

Lenses are the vocabulary of photography. The more you have at your command, the better you can express yourself. The lens furnished with your camera is a "normal" lens: It offers a field of view of 45 degrees or so, about what your eyes see. It comes closest to being an all-purpose lens. It is fast; that is, it can be opened up to wider f-stops than most other lenses.

A lens is defined by its focal length, the distance from the film plane to the center of the lens. On a 35mm camera with a normal lens, this is about 50mm. Anything much shorter than that is considered a wide-angle; anything much longer, a telephoto. All the focal lengths in this handbook are for 35mm cameras.

Telephoto Lenses

Your first new lens will probably be a telephoto. Telephotos not only pull in distant subjects, they also produce flattering portraits and dramatic foreshortening in landscapes. Their shallow depth of field easily separates foregrounds from backgrounds.

Telephoto focal lengths extend beyond 1000mm, but the most practical are between 80 and 300mm. Try a telephoto in the 80 to 135mm range for your first purchase. These are easy to carry and good for portraits, candids, sports, and landscapes. Look for the fastest lens you can afford—the one with the largest aperture. With a larger aperture, it is easier to focus in dim light and on distant scenes. Your second telephoto

A 28mm wide-angle lens takes in the entire scene, exaggerating the slide's length.

From the same spot, a 50mm normal lens sees a field of view similar to what our eyes take in.

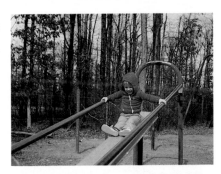

A 135mm telephoto zeroes in on the child, throwing the background out of focus.

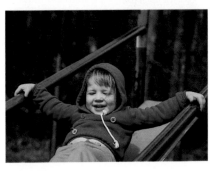

A beanbag helps to steady a telephoto lens. The stronger the telephoto, the more it accentuates camera movement.

The slowest safe shutter speed for hand-holding a camera corresponds to lens length: $1/_{250}$ for a 200mm telephoto, but $1/_{30}$ for a 28mm wide-angle.

- **You can buy a multiplier, or teleconverter, for your telephoto (not your zoom) and have the equivalent of a second lens at minimal expense. A 2x multiplier doubles the power of the lens, converting a 200mm into a 400mm. The penalty is a bit less sharpness and a much smaller maximum aperture.**

An 80 → 200mm zoom lens

should be about twice as strong as the first, in the 200 to 300mm range—a lens long enough for dramatic sunsets and distant action, like skiing and surfing.

Above these focal lengths, the *catadioptric,* or "mirror," telephotos are the best bet. They are shorter and lighter than conventional telephotos and easier to hand-hold at slow shutter speeds. A 500mm mirror lens will bring football action up to sideline size from your stadium seat. The disadvantage of these lenses is that they have fixed apertures and cannot be stopped down to compensate for slow shutter speeds. Also, their mirror optics turn out-of-focus bright points in the picture into distracting doughnut-like shapes.

Zoom Lenses

Zoom lenses permit you to change focal lengths without changing lenses. There are wide-angle zooms, telephoto zooms, and zooms that range from moderate wide-angle to short telephoto. The chief advantage of zooms is flexibility in framing from a fixed position. A single zoom can take the place of several fixed-length lenses. With an 80→200mm zoom, for example, you can shoot a portrait at 80mm, a candid at 135mm, or a distant skier at 200mm.

To zoom or not to zoom? The choice depends on your techniques and objectives. To have the zoom's flexibility, you

Use telephotos for dramatically compressed motifs. The longer the telephoto, the stronger the foreshortening effect. Crop tightly, without showing the edge of the pattern. A 200mm lens gives the impression that these row houses extend indefinitely.

A telephoto can pull in background, making it seem much closer than it really is. Here, a 400mm lens presses the tower and the dome together, though they are blocks apart. Use this effect also when you want to make a mountain, cliff, or tall building loom in the background. Place your foreground subject low in the frame.

When you can't get near, a telephoto will bring your subject close, as a 200mm lens did with these deer. In effect, telephotos narrow the field of view. A telephoto's magnification power (on a 35mm camera) equals its focal length divided by 50mm. For example, a 300mm is as strong as a 6x pair of binoculars.

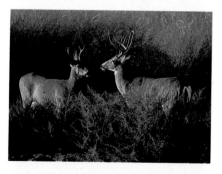

Medium-length telephotos (85 to 135mm) are excellent for portraits, as they show faces in good perspective. In this lively candid, a 105mm telephoto's shallow depth of field softens the background into an undistracting blur. Use a telephoto any time you need selective focus of this sort.

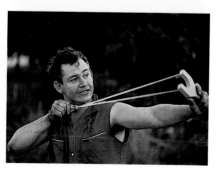

must be willing to put up with its disadvantages. Zooms are expensive, heavy, and slow—most are no faster than f3.5. But unlike early models, modern zooms produce images that compare in quality to those of fixed-length lenses for all but the largest enlargements.

Wide-angle Lenses

When you can't squeeze everything you want into a picture with a normal lens, you need a wide-angle. These lenses are also useful for compositions requiring great depth of field, for hand-held shots at slow shutter speeds, and—because they alter proportion—for dramatizing size and angle of view.

A useful first wide-angle is a 28mm lens. This focal length complements the 50mm normal lens and is reasonably priced. Ultra wide-angles, from 13 to 20mm, show a perspective that seems exaggerated, even distorted.

Fisheyes—lenses with a field of view of 180 degrees or so—do distort, turning straight lines to curves except in the center of the frame. Some give a full-frame image, others a circular one. The effect is dramatic, but the novelty wears off quickly, so think carefully before buying one of these expensive lenses.

A wide-angle lens offers greater depth of field than normal or telephoto lenses. Here, a 24mm lens keeps both the background and the open, beckoning gate in the foreground in focus.

Use wide-angle lenses to exaggerate proportions. A 17mm lens produced this sky-scraping steering column. Wide-angles serve well when you want to emphasize length or height, but the distortion makes them poor for portraits—unless you like long noses.

Group photographs (above), interiors, broad vistas . . . whenever you can't back up far enough to get everything in, that's the time to turn to your wide-angle.

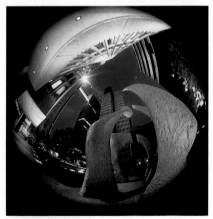

Fisheye lenses offer the widest angle of all, about 180 degrees—useful for special effects, very wide circular subjects (craters, racetracks, stadiums), and large indoor spaces. Some fisheyes produce circular images like this one, created by a 7.5mm; others fill the frame.

Close-up Equipment

The easiest way to take close pictures of small subjects like insects or coins is with a *macro* lens, which can focus both normally and close up. Among the most popular macro lengths are those near 55mm and 105mm. Some zoom lenses can also focus at close-up range.

Less costly than either macros or zooms are close-up lenses that screw on like filters. These come in varying powers of magnification and can be combined for higher powers. (Professionals prefer not to use several of these lenses at once, however, because of reflections from their surfaces. If you do combine them, be sure to put on the strongest lens first to reduce this effect.) To keep your image as sharp as possible with screw-on lenses, it's best to shoot at f8 or an even smaller aperture.

For magnification of more than half life-size without resorting to macros, it's best to switch from screw-ons to either

For close work: 1) a bellows and 2) an extension tube increase lens-to-film distance, unlike 3) a close-up lens, which screws on like a filter. In some cases, 4) a split-field lens is useful; it provides two zones of sharp focus, one close and one at a distance.

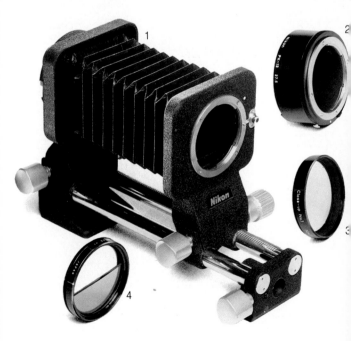

● *In a pinch, you can shoot acceptable close-ups even without close-up equipment. Use an SLR camera with a removable lens and through-the-lens metering. Open the lens to its widest aperture, then take off the lens and reverse it, holding it firmly against the lens flange on the camera body. Set the shutter speed shown by the meter, and focus by moving the camera back and forth. This doesn't work on all cameras; on some, such as shutter-priority automatics, you'll need to make test exposures.*

bellows or extension tubes. Both these devices increase magnification by moving the lens farther from the film. The extra distance causes light loss, so first set camera-to-subject distance and focus. Next set the exposure, using the through-the-lens meter. If there is too little light for the meter, remove the close-up attachment and meter normally through the lens. Hook up again and increase the exposure according to your extension's instruction sheet.

Depth of field is a problem with close-ups, so use as small an aperture as you can. When you can't get everything sharp, focus on the foreground center of interest and let the rest of the picture make an out-of-focus background.

Changing focus changes magnification, so if you've got the size the way you want it, the easiest way to focus is to leave the focusing ring alone and move the entire camera back and forth.

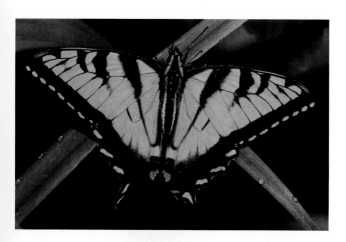

A macro lens (left) took this portrait of a butterfly. Specially designed for close-ups, macros retain better sharpness from image center to image edge than other close-up accessories.

Filters

● *Polarizing filters and dark red filters can fool some through-the-lens light meters. Check your camera instructions. If in doubt, meter without the filter, then put it on and, with the camera on manual control, increase the exposure according to the filter factor.*

Here are some commonly used filters, together with their filter factors and suggested uses. Many other filters exist; experiment with them and learn what you can do with them.

Filters change the color, quantity, or quality of light. Most mount on your lens by screwing directly into the front threads or by means of special adapters. There are filters for black and white film, for color, and others for both. *Polarizing* filters deepen color, darken skies, and reduce glare. *Color-conversion* filters balance light to suit your film, enabling you to use indoor film outdoors and vice versa. *Neutral density* filters compensate for excess light by reducing all colors equally. *Skylight* and *ultraviolet* (UV) filters reduce blue tones and cut haze; many pros keep them on the lens as protection. Still other filters create special effects.

Strongly tinted filters require more exposure to offset their darkening effect. Most through-the-lens meters will compensate automatically. If yours doesn't, a *filter factor* will tell you how much to increase exposure (see table below).

Filter	f-Stop increase*	Filter factor*	What it does and how to use it
Ultraviolet (UV)	none	-	Cuts UV radiation haze common in distant shots; removes blue cast from high-altitudes and desert scenes. Use with daylight color and black and white.
Skylight (1A)	none	-	Warms blue cast in open shade and on overcast days, has some UV effect. Designed for use with color films.
Polarizing	$1\frac{1}{3}$	2.5x	Strengthens color, darkens sky, reduces reflections and glare. Use with all light sources, all films.
Pale orange (81C)	$\frac{2}{3}$	1.5x	Warms color in shade or cloudy weather. Use with color film in daylight.
Blue (80A)	2	4x	Corrects color when using daylight color film under tungsten light.
Amber (85B)	$\frac{2}{3}$	1.5x	Corrects color when using tungsten film in daylight or with electronic flash.
Magenta (FLD) Orange (FLB)	1	2x	Magenta corrects daylight color film for fluorescent light; orange corrects tungsten color film for fluorescent light.
Neutral density (ND)	varies		Allows you to choose wider aperture or slower shutter speed with no color shift. Available in varying densities. Use with all films, all light sources.
Yellow (8 or K2)	$\frac{2}{3}$-1	1.5-2x	Darkens sky, increases contrast, and reduces bluish haze. Use with black and white film.
Red (25A)	$2\frac{2}{3}$-3	6-8x	Dramatizes landscapes, exaggerates water, sky, and cloud contrast. Use with black and white film.
Green (11 or X1)	$1\frac{2}{3}$-2	3-4x	Improves skin tones in outdoor portraits, and in tonal rendition of foliage. Use with black and white film.

*Filter factors indicate how much exposure must be multiplied to offset the light loss caused by use of a filter. Opening up one stop *doubles* aperture size, so a filter factor of 2 means an increase of only *one* stop. Factors listed are approximate, since they may vary according to brand.

If you correctly expose ground-level scenery, you're likely to end up with a washed-out sky (upper). A polarizing filter darkens blue sky and brings out clouds (lower) in a band 90 degrees away from the sun. If you use an SLR, you can see the effect in the viewfinder. Rotate the filter to find the best degree of darkening. On other cameras, note the best position for the filter by eye, then mount the filter on the lens and turn it to that same position.

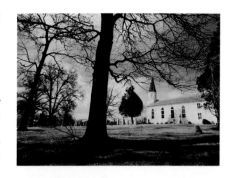

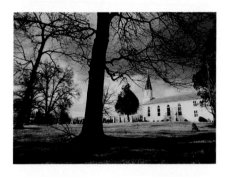

To banish annoying reflections (upper), use the polarizing filter (lower). It works best when the camera is at a 45-degree angle to the reflecting surface, such as glass or water. Again, rotate the filter to find the best effect.

Even when there are no obvious reflections, polarizers can enrich colors by removing glare. To see how, experiment with one on a bowl of shiny fruit.

A diffusion *filter creates a soft-focus, misty appearance, especially good with backlighting. (Some have a clear center, so you can frame a sharply focused main subject in a ring of softness.) You can get similar effects by fastening a piece of light cloth—stocking or cheese-cloth—over the lens, or by smearing a light coat of petroleum jelly on a skylight filter. Even simpler: Breathe on your lens and shoot before the fog clears.*

Starburst *or cross-screen filters turn bright points of light into multi-rayed stars. You can improvise a four-ray starburst filter by taping a piece of fine-wire window screen over the lens.*

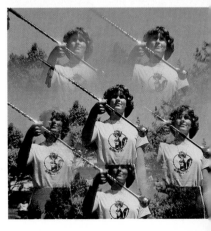

A prism *or multiple-image filter repeats the main subject of the photo, from two to six times depending on the filter. A single subject against a simple background works best.*

Tripods

● *To steady a wobbly tripod, hang a camera bag or any other heavy item from it.*

The sturdier, the better: 1) a regular full-size tripod; 2) a C-clamp; 3) heavy-duty model with center post reversed for close-up work; 4) mini-tripod for travel and table-top use.

To take photos at slow shutter speeds, you need a tripod sturdy enough to hold the camera without moving. Steadiness is also critical in close-up and telephoto work. When you're buying, extend the tripod legs all the way, then lean on the camera mount with some pressure and try to wiggle it. If it moves, try another.

When using the tripod, guard against camera shake. Trip the shutter with a cable release or the camera's self-timer. (On SLRs, the movement of the mirror may jar the camera, but many models allow you to lock the mirror in the up position before you shoot.)

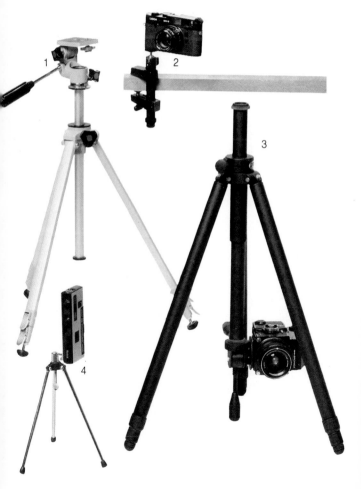

Flash

● *Eyeglasses and mirrors can throw the flash right back into your camera lens— easy to avoid if you make sure that such surfaces are at an angle to the flash.*

● *Before you fire the flash, try previewing the scene with a wide-beamed flashlight. It will help you find unwanted reflections, show you where the shadows will fall, and reveal how the light will look on your subject.*

● *You can use your flash to create a flowing blur of motion ending in a sharp image. Turn on all the room lights. Disconnect the flash from your camera. Mount the camera on a tripod. Set the aperture one stop smaller than normal for your flash-to-subject distance. Set the shutter on B, and open it as your subject begins to move. After one second fire your flash with the manual control button, then close the shutter.*

When you can't take pictures with existing light, you need an electronic flash. Many cartridge and instant-print cameras still require bulb flashes, but 35mm SLRs don't. An electronic unit will fire thousands of times and is safe and inexpensive to operate.

A connecting cord or camera-top "hot shoe" mount triggers the flash when the shutter snaps. Most cameras have a particular shutter speed synchronized for flash—commonly $1/60$. Yet the light pulse of the electronic flash itself lasts only $1/500$ to $1/50,000$ second. This duration (and the f-stop), *not* shutter speed, determines exposure. That's why you can freeze fast motion with flash. But you must keep the shutter no faster than the "sync speed."

If you have a nonautomatic flash, the dial or chart mounted on it shows you the right f-stop to use. This will vary according to film speed (ISO) and the distance from flash to subject. You can measure distances simply by focusing on your subject and reading the distance from the scale on the lens. Outdoors at night with flash, open up an extra stop, as there are no surfaces to reflect light back into the picture.

You can also calculate exposure by using your flash's *guide number,* listed in the manual, and dividing it by the flash-to-subject distance to find your f-stop. The guide number depends on flash strength and film speed.

An automatic flash determines exposure with a sensor. This "eye" measures light reflected from the scene and cuts off the flash when the exposure is correct. Some automatic flashes allow a choice of f-stops, in which case you must set both the lens *and* the sensor.

A flash sensor can be fooled just as a light meter can (see pp 28-31), so it's a good idea to bracket, by adjusting the f-stop (*not* the shutter speed).

To diffuse harsh light from your flash, use a bounce card, or drape one or two layers of white cloth handkerchief over the flash. (Don't do this with flashbulbs!) Increase exposure one stop for each layer. Automatic flash units will make this correction themselves, if you don't cover the sensor.

Flash attachments, clockwise: 1) nonautomatic electronic flash; 2) tilting-head automatic electronic flash on a hot shoe mount (note the light sensor at the base of the unit); 3) head tilted up, with bounce card attached; and 4) flash unit detached, with sensor mounted in hot shoe.

Many automatic models store unused power from one flash for the next one. This extends battery life and shortens recycling time between flashes.

A *capacitor* accumulates power from the batteries and discharges it when you fire the unit. If you have not used your flash for several weeks, you need to bring the capacitor back to full storage capacity by firing and recharging the flash several times in a row before using the unit to take pictures. This procedure, called "re-forming" the capacitor, ensures strong flashes and short recycling times. Storing your flash with the capacitor loaded helps as well. Just wait until the ready light goes on, then switch off the flash without firing it.

The most common place to mount a flash is directly on the camera. This works well for snapshots, but produces hard shadows behind subjects and flat, harsh portraits. For many units you can

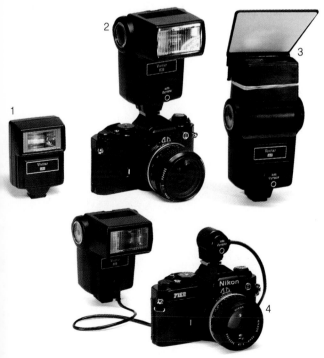

For portraits, try bouncing your flash from a white wall instead of the ceiling. This technique produces pleasing sidelighting and avoids the shadowed eye sockets typical of ceiling bounce. If you don't want strong shadows, place a reflector on the side of your subject away from the wall.

buy a cord that lets you hold the flash at arm's length, where it will give three-dimensional "modeling" to faces. For still softer, more diffuse light, an off-camera or tilt-head unit can "bounce" the flash off walls, ceilings, or a card mounted on the flash itself. (Don't bounce off a colored surface unless you want that color to tint your picture.) In most rooms, bounce flash needs about two stops more exposure, depending on how near and bright the reflecting surfaces are. It's wise to bracket. With a nonautomatic flash off camera, remember to figure your f-stop based on flash-to-subject distance, *not* camera to subject.

Bounce is easier with an automatic camera-flash system that reads light striking the film, or with an automatic flash whose sensor faces forward no matter where the flash is aimed. Then you can even bounce off a wall behind you without having to calculate f-stops.

Light from a flash unit mounted on the camera may bounce back from the pink retina of the subject's eye—human or animal—giving a disconcerting "red-eye" effect.

To eliminate red-eye, simply move the flash slightly away from the camera, or make sure that your subject is not looking directly into the camera lens.

Flash

Direct flash, from a unit held away from the camera, avoids the flat lighting of camera-mounted flash, but may cast unwelcome dark shadows. For this picture (right), the flash was far off-camera—on a stand above and to the right of the photographer.

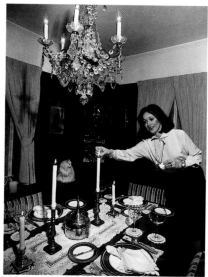

Here, a tilting-head unit mounted on a hot shoe bounces the flash off the ceiling, spreading soft light evenly over the room and the table.

Don't expect your flash to do the impossible (below). Tiny built-ins reach no more than 15 feet, powerful larger units 70 to 100 feet.

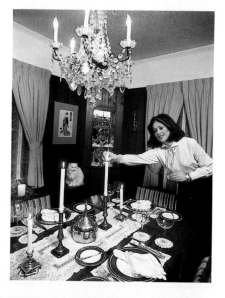

Popular Pictures

Here are the picture-taking situations and conditions you'll meet most often — techniques, tips, and ideas in alphabetical order from *Activities Outdoors* to *Underwater*.

Activities Outdoors

Ball games, hikes, cookouts, parades — all are opportunities to exercise your photographic skills. Following the action with your camera can be as much fun as the event itself. Preset a fast shutter speed to stop movement.

For baseball games, focus on the base before the runner gets there, so you can catch him being tagged out or sliding in safe. With a telephoto lens, try for the big swing of the batter and the leap of the outfielder. Focus and wait for the action to arrive — a good rule for photographing all outdoor activities.

For good pictures from the sidelines you will need a 200 or 300mm telephoto. But take care when you focus. The telephoto's depth of field is very shallow. And don't forget the cheering fans.

To catch action on the ski slopes, move ahead, choose a position, prefocus on a likely spot, and shoot when the skiers arrive. If you are going to pan the action, plan ahead. Pick a fixed object along the skiers' path, and focus at

Pick your vantage point well ahead of time when you want to photograph a parade. A corner makes a strategic position, since turning marchers leave a clear field of view toward the next group.

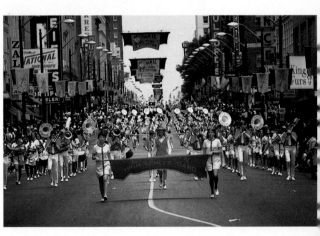

A wide-angle lens summons up the aroma of a Cape Cod clambake by concentrating on the lobsters and clams. Look for strong foregrounds whenever you're photographing people cooking or working on something; a side view here might not have made as effective a picture.

A setting of $^1/_{500}$ will freeze all but the fastest playing-field action. Use fast film and a telephoto. Be ready to click your shutter an instant before the action reaches its peak, as at this small-fry football game.

At a game of tree stump tug-of-war, a low camera angle isolates the foreground players against the sky. Inclusion of the background players as well suggests the number of participants.

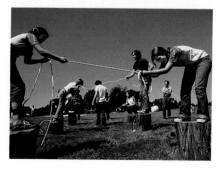

the point where they will pass it. Aim your camera at the skiers, following their progress. As they pass the object you've picked, release the shutter while continuing to follow them with your camera. Follow-through is essential when shooting moving objects.

To shoot a parade, you'll want to be there early and in front. Even so, a surging crowd can make things difficult, so practice aiming while you hold your camera high above your head. Try to get a program ahead of time. If you know what's coming, you'll be able to change lenses if necessary.

On a hike, early morning and late day will give you the best light, and a moving subject will often make the most interesting picture. Photograph fellow hikers walking up the trail toward you. A wide-angle lens will combine the rugged trail in the foreground with hikers trudging along farther back.

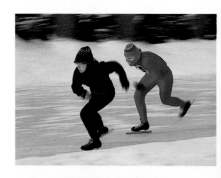

Panning streaks the background behind skaters at Lake Placid, New York, and conveys their speed more vividly than a perfectly sharp image would. With a telephoto, you can pan at faster speeds — $^1/_{60}$ or $^1/_{125}$ — than you can with a normal lens.

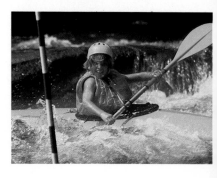

A fast shutter speed, $^1/_{500}$, freezes a young kayaker's paddle in midair. For water sports a telephoto is a must. A skylight or UV filter makes a useful lens protector when you're shooting around water.

Candids

A candid shot is one the photographer doesn't set up. Sometimes candids have more value than posed pictures because they capture the natural behavior of people who are unaware that their picture is being taken. The right timing is essential in candid photography. One key to success is preparation.

Automatic cameras are ideal for candids. But even with a manual exposure camera, it's easy to set the controls beforehand. Try prefocusing your camera and presetting the exposure. This way if you are sitting in a sidewalk cafe, walking along a street, or exploring a market, you can quickly bring your camera to your eye and shoot.

For fast work outdoors, you want both a high shutter speed and a small f-stop — $^1/_{250}$ and f8 or smaller. Since often there is no time to focus, you need the depth of field that small apertures give. Fast film — ISO 400 — is almost always best for candid photography because it allows you to move in and out of different lighting conditions and still keep the high shutter speed/small f-stop combination you need.

If you're indoors or in dim light outside, set the lens opening and shutter speed for existing light. At these larger

The ready-for-anything setting, good for outdoor candids or sudden action: f16 at the appropriate shutter speed. Focus at 12 feet. With a 50mm lens everything from 7 to 30 feet will be in focus, so you can grab the shot before it's too late. Use fast film and you won't blur the action, even in the shade.

These students were too involved with themselves to notice the photographer, who waited for the right moment to shoot. Catching that moment may not allow time for perfect composition; this frame needed cropping to eliminate a distracting tree.

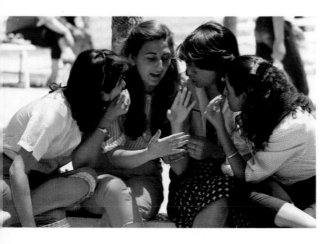

- *Use the right equipment for candids. Photographers have discovered that all-black camera bodies attract less attention than those with shiny trim. An autowinder will advance your film for you and keep obvious film-winding from giving you away. A telephoto will blur a cluttered background or pick an individual out of a crowd.*

- *An inconspicuous way to carry your camera for candids: Give the strap two or three turns around your wrist, so you can grasp the camera comfortably in your hand, finger near the shutter release. This way you can hold the camera at your side or even behind your back. When the moment's right, raise the camera casually to your eye, shoot, and lower it quickly.*

apertures, you'll have to keep refocusing unless you can maintain an even distance from each of your subjects. A fast wide-angle lens is useful in dim light because of its great depth of field.

A Low Profile

When you're shooting candids, stay casual and relaxed. The sooner people get used to seeing you with your camera, the sooner you'll get good pictures.

Begin candid picture-taking with your family and friends. It helps to know your subjects, and you can get a lot of good practice in familiar surroundings. When people begin to ignore you, it's your chance to catch them in a moment of conversation, a typical expression, or a show of emotion.

If you're away from home and your subject notices what you are up to, ask permission before you shoot. Usually people won't object, particularly if you work quickly. If someone does, move on. If possible, get acquainted with strangers before taking their picture. Most people like to have their pictures taken. Often, your problem may not be refusal but overacting and stiff posing. Ask, "Please don't look at the camera." Try to capture details of the environment in your picture—something your subjects are working with, or a significant background. You don't want to control people. Be patient until they assume a natural pose in an appropriate setting.

When you want to attract the least amount of attention, set your camera and shoot without raising it to your eye. One way to do this is to pull down on the neck strap until it is taut. With both hands, steady the camera against your chest and point the lens toward the subject. Release the shutter with your thumb. Or hang the camera from your shoulder, holding it against your side with one hand. Turn your body—and the

58

Sometimes your camera's self-timer can help you with candids: Set the camera on a table, and aim it at your subject. Trip the timer and look elsewhere as the shutter clicks. If there is enough noise to mask the timer's buzz, you seem not to be taking pictures, so people relax.

lens—toward your subjects while you look the other way. Then click.

You can also use camouflage. With your camera in hand, casually sling a coat over your arm so as to hide everything but the lens.

At first, surreptitious shooting may be hard, because your aim will be uncertain. One technique that helps is to position your shutter finger (or thumb) so that it points the same way as the lens. A wide-angle lens, because of its greater coverage and depth of field, is best for these away-from-the-eye techniques.

If you must stalk your quarry, find an unobtrusive camera position such as a doorway, a view across a walkway, or a lookout from a window. Focus on a spot and shoot when your subject arrives. You're more likely to go unobserved with a telephoto lens.

But remember, good candids don't have to be surreptitious—just natural.

Put people at ease for the natural feel of a candid. A cheerful, open, courteous approach evoked this smile from a street vendor in Ulm, West Germany. Don't use the camera as a shield to hide behind; your subjects will sense your unease. You need patience for candids— and plenty of film.

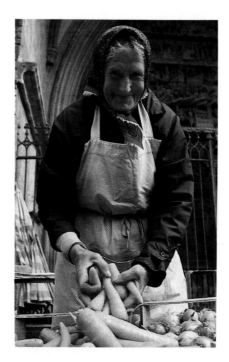

Celebrations

The camera is almost always a welcome guest at birthdays, weddings, holiday feasts, graduations, bar mitzvahs — any occasion when people gather to celebrate. And one photo is hardly ever enough. Remember the theme of the occasion as you plan your pictures. You'll want to emphasize the main event in a series of photos that tell a story. Over the years your photographic skills will build a treasured family history.

Parties

Try to get candid shots as guests arrive and greet each other. Have the camera loaded, with the flash and focus set, and place it on a table near where people will enter. If you are host or hostess, you might want to enlist the help of a photographer friend.

In some situations a flash will distract people and upset the mood you want to record, so switch to a fast film, pushed if necessary, and rely on whatever light is available without flash. For best results indoors use a wide-angle lens with a large aperture.

Either way, you can shoot an entire group of people sitting around the dinner table, or record a bountiful feast before guests begin to eat. If you do use

Flash, bounced off the ceiling, lights up the climax of a birthday party. Reflected light from the cake's white icing illuminates the little girl's face. If you have a 35mm camera, shoot your flash with a shutter speed slow enough to let the candles register — usually no faster than $1/15$. The slow flash shutter speeds on most cartridge cameras will pick up candle flames.

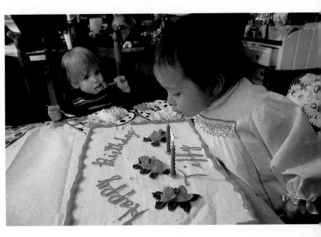

Set aside your best family photos of the year and use them to make holiday greeting cards, party invitations, and announcements for such occasions as graduations or births.

flash, bounce it off the ceiling to evenly illuminate the entire table or all the faces in the group. Or stand on a chair to spread the light around. Shooting across the width of the table will make flash fall-off less noticeable. If your lens will not take in everyone, ask some guests to stand behind those on the far side of the table.

Birthdays

Move in on the birthday child for close-ups, and for candle-blowing time. Slow down your shutter speed to register the candle flame, and remember that you need a tripod or some other support for slow settings. You'll probably need flash in the darkened room. If you can, try for two pictures, one of the candle-blowing and another of the triumphal scene when the candles are out.

At graduation keep in mind that the black gowns will throw your light meter off. Stop down a notch or two more than the meter recommends. Or take a reading from your subjects' faces or a gray card. Try to catch the mood of such outdoor festivities by looking for details and incidents that make the occasion special—a proudly displayed diploma, for instance, or an abandoned mortarboard at day's end.

As the guest of honor opens presents, you have another opportunity for candids. Watch for the moment when the recipient rips off the ribbons. Then turn quickly to catch the giver's expression.

A birthday party is a good time for an instant camera. You can give out prints right away and add excitement to the party—and photograph someone admiring your photographs.

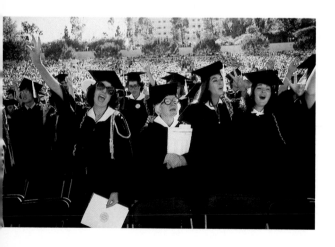

● *For fun at Halloween: Faces lighted only from below appear weird and ghoulish. Pose someone close over an open-topped jack-o'-lantern, or light up some trick-or-treaters with flash from the floor. Put a colored handkerchief over the flash for added spookiness.*

Holidays

Generally, your best choice for important holiday pictures will be either bounce flash or fast film with existing light—and sometimes both.

A lighted Christmas tree is one such situation. Use a combination of flash and existing light. To shoot the tree, turn on the tree lights and all the room lights. Use the f-stop setting for a normal flash shot and a slow shutter speed (see table, p 68). The side of a doorway can steady the camera. The flash will light up the tree, and the slow shutter setting will allow the tree lights to burn in, resulting in a shining Christmas tree. If you include the family, be sure they hold still so they won't leave ghost images of movement.

On Thanksgiving or Passover, you'll want to photograph the family around the traditional table. Follow the same procedure as for a dinner party. Stand on a chair for a view of the table setting that excludes background clutter. At a Hanukkah celebration, you can pose a small group of family members as someone lights the menorah.

A lighted Halloween pumpkin presents you with a similar challenge: If there's enough light from the candles, you can get a dramatic picture without flash. Or add flash bounced off the ceiling or wall to show the outside of the pumpkin. Because you'll need a slow shutter speed, use a tripod or brace the camera. If you pose children over the pumpkin, be sure they hold still. Outdoors, bounce the flash off a piece of white cardboard held out of the frame. For an eerie, Halloween-style effect, bounce it off something red instead.

Take close-ups of goblins, witches, and other imaginative characters in the house before the trick-or-treat rounds. Then keep a camera and flash handy by the door to shoot the passing parade.

A treasure-filled Easter basket offers the chance for charming candids. A medium-length telephoto lens keeps the camera far enough away to avoid distracting the child.

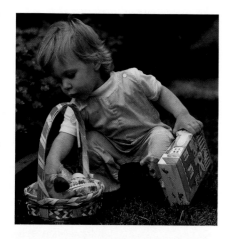

Candles as the only light source add warmth and intimacy to an Advent scene. You'll need a slow shutter speed and a wide-open lens — $^1/_{15}$ and f2, if your film is fast (ISO 200-400). But bracket to be sure.

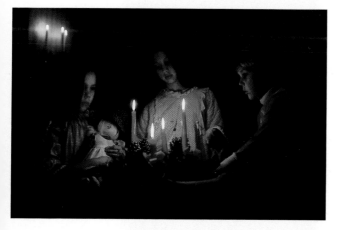

Strong flash lights up the lion at a nighttime Chinese New Year celebration. A very slow shutter speed registers the exploding firecrackers. For nighttime festivities, remember to keep your subjects within the reach of your flash. Outdoors with flash, open up one stop more than usual.

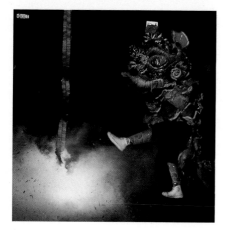

Weddings

Flash is usually the answer to good wedding photography. With an automatic electronic flash to measure the right amount of light, you will be able to shoot quickly without stopping to change f-stops.

Talk to the bride and groom and their families in order to plan the kinds of pictures you'll be taking. Then make out a rough schedule for yourself.

You might begin by photographing the bride in her dressing room. Make a portrait by natural light from a window, or take a picture of her reflection in a mirror. Shoot at an angle to the mirror so you won't appear in the picture.

As the bride arrives for a church ceremony, you may have a chance to make

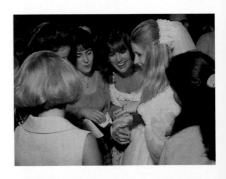

At weddings, be ready to take quick candids like this one of the bride and her friends in a private moment. If you're photographing groups with flash, it helps to have all the people about the same distance away.

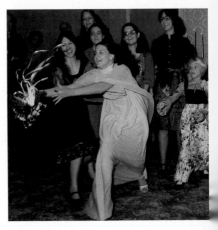

Flash helps to catch the action as a bridesmaid lunges for the bouquet. If you plan to photograph lots of celebrations, consider buying a power winder to advance the film and cock the shutter automatically. You'll miss fewer pictures.

pictures outdoors. And if you have the clergyman's permission, you will be able to photograph the bride as she walks up the aisle on her father's arm.

To shoot the vows and the ring ceremony, you'll need a short telephoto lens. Position yourself off to one side and in back of the altar. Do not use flash. With existing light and an exposure of up to $1/2$ second, you'll get a prettier scene. To steady the camera, rest it on a railing or hold it against a column or the wall. Afterwards, the rice throwing is a must. Position yourself in front of the church so you can see the couple clearly in your viewfinder as they come out the door.

For the cake cutting, you may want a carefully composed portrait. For other events, such as the dance or the escape to the decorated car, quick candids are more appropriate. And keep an eye out for tearful parents, laughing children, and smiling friends.

Outdoor greenery makes an ideal frame for a formal wedding portrait. The photographer used flash to fill in shadows caused by backlighting, but you can also lighten them with a reflector. Or you can expose for open shade.

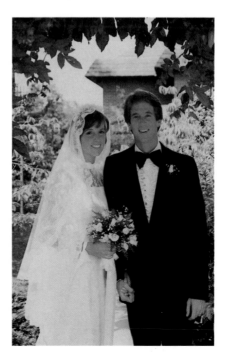

Children
and Babies

Keep your camera handy, loaded with fast film. Let the kids get used to it. The more often they see you with your camera, the more easily you will get spontaneous, natural shots.

Indoors, the best way to stop movement is to use flash. Bounce or diffuse it to soften the light. If you find that the flash disturbs youngsters or intrudes on the activity you want to photograph, use existing light. Even under tungsten light, ISO 400 film will often give you good results if you don't mind the warm tone light-bulb illumination creates.

Outdoors, a bright cloudy day will make your job easier—you can change camera angles without worrying about shadows. On a sunny day, choose the shade of a tree or the house. Or place your subjects with their backs to the sun, and meter their faces.

Children may be shy when first confronted with a camera. Take your time. Play along with games and questions. Eventually the child's nature will emerge, and you will capture it on film.

You can often make friends with your subjects by showing them your equipment and allowing them to look through the viewfinder. If they want to make faces for the camera, let them; the

● *If you're taking pictures of children at home, settle down in the child's room. Get the child talking about favorite toys, books, or hobbies. Shoot while your subject arranges some belongings for a picture, then photograph the proud owner with the array.*

● *Sometimes the tried and true is what everyone wants—the baby in the bathtub; in the highchair, with sticky fingers; romping with the dog; playing with Mother's hair or Grandpa's leathery hands.*

To evoke a reaction from a child—and attract attention away from the camera—include a prop such as a beloved teddy bear. A pet will work even better. Keep the background simple and fill the frame.

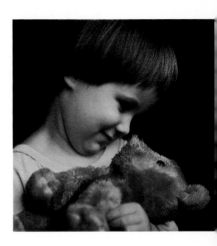

playacting might yield a more revealing picture than any formal portrait. And when they get bored with hamming it up, you'll get some natural poses, too.

For younger subjects, you need to plan ahead. Anticipate the next move if a baby is playing with toys or a toddler is starting a stroll. Focus on a toy the baby will pick up or a doorway through which the toddler will pass. Wait for your model to oblige, and shoot.

Be ready for spontaneous behavior. You'll get the best pictures when the baby is most energetic — after a nap or around mealtime or playtime.

You must be quick to catch a moment like this between children. Preset your exposure and take a lot of pictures. It may be easier to get the children in a playful mood if you enlist a parent's help.

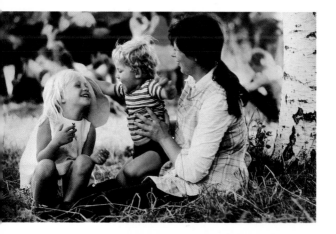

Get down to eye level to capture a child's facial expressions. If you want a crawling or a sitting shot, you may have to lie down to get it. Be ready with your camera when the baby goes exploring.

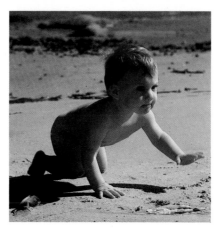

Existing Light

Existing light, or *available light,* is daylight indoors or twilight outdoors, as well as any artificial light that happens to be on the scene. The terms are used to describe light dimmer than ordinary outdoor daylight. Pictures taken by existing light instead of flash retain the natural, realistic appearance of the subject and setting.

● **When your meter can't read an overall scene because the light is slightly too dim, see if you can get a reading from a white surface such as a piece of paper. If so, increase your exposure 2¹/₂ settings from that reading for a good rendition of the entire scene.**

These exposure settings are starting points only. In low light it's best to bracket. At speeds slower than ¹/₃₀ use camera support.

Techniques

If you're photographing people, pose them under evenly distributed lighting — not in the contrasty glare near a sunny window. You can photograph favorite spots in your home, with your most treasured possessions arranged in a setting to show them off. To reduce contrast, turn on all the lamps and overhead lights in the room.

For existing-light shots, high-speed film and a lens you can open to f2 or wider are best. Then you can hand-hold

Exposures for Existing Light

Subject	ISO 64-100		ISO 125-200		ISO 250-400	
Rooms in tungsten light						
Average	$^1/_8$	f2	$^1/_8$	f2.8	$^1/_{15}$	f2.8
Bright	$^1/_8$	f2.8	$^1/_{15}$	f2.8	$^1/_{30}$	f2.8
In bright fluorescent light	$^1/_{60}$	f2	$^1/_{60}$	f2.8	$^1/_{60}$	f4
Church interiors	$^1/_8$	f2	$^1/_8$	f2.8	$^1/_8$	f4
Sports events						
Indoors	$^1/_{30}$	f2	$^1/_{60}$	f2	$^1/_{60}$	f2.8
Outdoors at night	$^1/_{60}$	f2	$^1/_{60}$	f2.8	$^1/_{125}$	f2.8
Stage shows						
Average light	$^1/_{30}$	f2	$^1/_{30}$	f2.8	$^1/_{30}$	f4
Bright light	$^1/_{30}$	f4	$^1/_{60}$	f4	$^1/_{60}$	f5.6
Circuses	$^1/_{30}$	f2	$^1/_{30}$	f2.8	$^1/_{60}$	f2.8
Ice shows	$^1/_{60}$	f2	$^1/_{60}$	f2.8	$^1/_{125}$	f2.8
Spotlighted acts	$^1/_{60}$	f2.8	$^1/_{60}$	f4	$^1/_{125}$	f4
Christmas lights	$^1/_4$	f2	$^1/_4$	f2.8	$^1/_4$	f4
Candlelit faces	$^1/_4$	f2	$^1/_8$	f2	$^1/_8$	f2.8
Fire (flames)	$^1/_{60}$	f2	$^1/_{60}$	f2.8	$^1/_{125}$	f2.8
Subjects lit by firelight	$^1/_8$	f2	$^1/_8$	f2.8	$^1/_{15}$	f2.8

Lighting from a second window to the left illuminates this cozy scene. The window is not in direct sun, so it lets in only diffused light, without any harsh contrasts to spoil the picture's natural look.

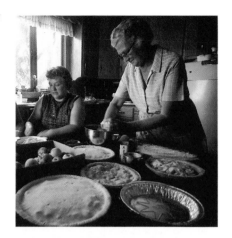

An evening campfire calls for high speed film and a fast lens. If your meter isn't sensitive enough for a close-up reading of your subjects' faces, use the table (opposite) and bracket.

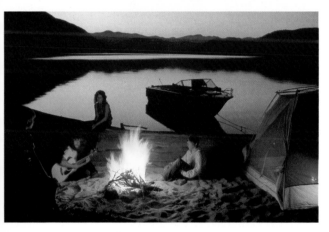

Look for combinations of light. Here, bright light from a table lamp supplements the dusky natural light in a restaurant overlooking the Seine. Daylight film, by enhancing the warm reddish hues, adds intimacy to the scene. The slow shutter speed blurred the cover as the waiter lifted it from the platter.

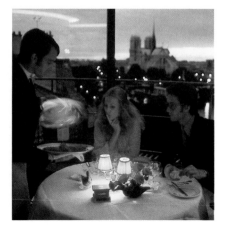

Fluorescent lighting gives daylight slide film a greenish cast. An FLD filter corrects this problem. An FLB filter with tungsten film may give even better results. Color print film produces acceptable pictures in fluorescent lighting, without filters; the color can be improved in printing.

Most church interiors aren't lit throughout, as is this one in Boise, Idaho. In dimmer churches or museums, make long exposures with the camera on a tripod. A good substitute for a full-size tripod is a portable tabletop model, which you can brace against walls or columns.

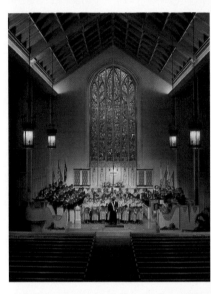

A telephoto lens shows the rich hues of a stained glass window in Chartres Cathedral. To photograph stained glass, use daylight film. Expose for the light of the window, not the dim interior light. If you can, keep your camera vertical and level with the window to avoid distortion.

● **When shooting any picture that involves a beam of light (flashlight, sunbeam, or laser) in dim surroundings, you can make the beam stand out by blowing smoke through it.**

your camera in all but the dimmest light. The higher the film speed, the less light you need. At shutter speeds slower than $1/_{30}$, you need a tripod. But sometimes a tripod is inconvenient or prohibited without special arrangements (as in some museums). Then, steady the camera against a flat surface as you shoot.

Weak light usually dictates a large aperture setting. Because of this, depth of field will be shallow, and not all of the picture will be sharp. But if you focus on a center of interest—a statue, the altar in a church, or the central figure in a room—the picture will *look* acceptably sharp. If you do want overall sharpness, use a wide-angle lens set at the smallest possible aperture. Adjust the focus while observing the depth-of-field scale on the lens to see how near and far the sharpness extends at the f-stop you're using (see pp 32-33).

A wide-angle lens is also useful when you want to photograph a broad interior area and you cannot move back far enough to take it all in. The 28mm is a good choice—wide enough for a broad view but handy for other photography as well. Keep distortion to a minimum by holding the camera level, at a height from which you can frame the view squarely. Line up the vertical and horizontal lines of the structure with the frame of the viewfinder.

The Right Film
Choose the correct film for the main light source. If it is daylight, use daylight color film; if tungsten, then Type B (tungsten) indoor color, unless you like the warm reddish tone that tungsten light leaves on daylight film.

At times there is a mixture of lighting. In museums, for instance, skylights may admit daylight, but they are supplemented by interior lights. In such cases, choose film for the stronger lighting.

Houses and Buildings

Buildings are splendid subjects for your camera. Consider which features of the building intrigue you most. Then pick the camera angles and time of day that will best show them off.

Composition and Light

Look for details that lend character or emphasize your reaction to the building. Pay attention to windows, doors, and decorative trim, which often form interesting patterns. Keep an eye out for textures too. A peeling wall or a weathered door can have visual appeal.

You can turn what would have been an ordinary picture of a building into a special one by thinking *when* to photograph it. If possible, study the effects of light at different times of day, even different seasons. Midmorning and midafternoon shadows will give a sense of depth to details. But consider too the warm glow of early sunlight, dramatic

● *Architectural details or decoration may tell more about a building than a picture of the whole structure.*

To dramatize a city building, use a wide-angle lens. Because the vertical lines converge, the building will seem to soar. Shoot from the roof down for an equally striking convergence. In the detail of this facade (above), shimmering reflections contrast with severe lines.

72

silhouettes at dusk, and muted colors under overcast skies.

Sometimes you'll want to take advantage of a building's setting. A driveway can lead your eye to a house; foliage or a gateway can frame it; pedestrians will give scale and atmosphere to a busy office building or museum.

Lenses

In the city, where working space may be tight, a wide-angle lens with its short focal length can be an asset, even though there will be some distortion.

If you want to avoid distortion, find a high spot. A facing building, stairs, or a nearby hill will let you take in the entire building without tilting the camera. To check for distortion, compare the vertical and horizontal lines of the structure in the viewer with the edges of the viewfinder frame. But don't hesitate to use distortion if you like the effect.

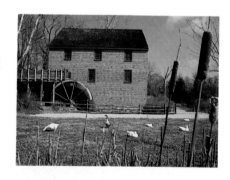

A foreground of cattails adds depth and balance to this frontal view of an old Virginia mill. Use a wide-angle lens and a small aperture on shots like this, to ensure that both building and foreground will be sharp.

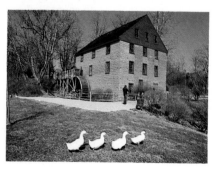

With a low, oblique camera angle, the lines of the mill rise from a point of interest in the foreground—the ducks. Oblique views of buildings often add interest, whereas simple head-on views may deaden a composition.

Landscapes

After people, landscapes are probably the most popular subjects for the camera. Few of us can resist a beautiful view, and when we see one, we often feel an immediate urge to raise the camera and shoot. Then, when the picture comes back from the lab, it's somehow not the landscape we saw.

But disappointment needn't be the result. There are ways to make your landscape photographs as memorable as the original experience.

Select and Frame the View

First analyze the scene. Determine what feature most attracts your attention. Is it the S curve of the stream that meanders across the landscape? The lonely farmhouse? The lazy-turning vanes of a windmill? Wave after wave of surging blue mountain ranges?

When you've identified the primary attraction, look for ways to play it up. What

● *Even for professionals, distance is the most difficult thing to photograph. In your landscapes, show depth by putting elements in the foreground, in the middle distance, and in the background. The eye travels to a light spot in a picture, so try to place one deep in your composition.*

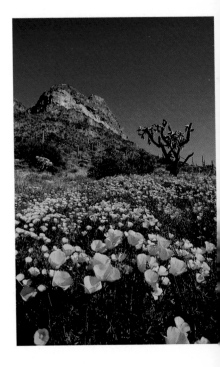

A wide-angle lens stopped down for maximum depth of field sharpens the focus from the golden poppies in the foreground to the mountain crag in the distance. Put more than one element in your landscapes. Here, the mountain, the cactus, and the flowers all add interest to each other.

seems to be the best viewpoint? A stroll up a nearby hill or a drive farther along the road may reveal more of the stream. A closer view can enlarge the farmhouse. A telephoto view can accent the height of the mountains by pulling them close to dwarf the foreground.

When you have chosen your view, frame it through the camera viewfinder to see what you are including. Turn your camera vertically. Do you like the scene better that way?

Lighting

Lighting sets the mood of your landscape. At sunrise or sunset, a few minutes make a great difference in the angle of the light. If you have time, study how light changes throughout one day and pick the best time to return another day for your picture. Changing seasons will also make a difference. Some of the spectacular landscapes published in

Watch that horizon. For a feeling of wide-open space in your landscape, place the horizon low in the composition to show an expanse of sky. Put the horizon high in most other cases, when you want to throw attention on the land itself. Try to overcome the inclination to let the horizon fall in the middle of the frame. Only rarely—for reflections in still water, for instance—is that placement effective.

Time of day makes a big difference in the appearance of your landscape. The setting sun casts a cool, blue shadow from the mountains toward the camera in this shot of the Grand Tetons (upper). But at dawn (lower), the rising sun bathes the same mountain peaks in a warm glow of brilliant orange, cast from behind the camera.

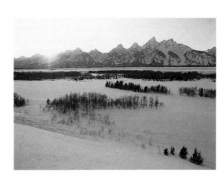

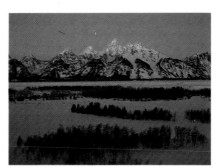

the National Geographic have required
many return trips to get the perfect light.

Center of Interest

Silhouetted cactus sets off a Mexican sundown, its colors diffused by desert dust. Use a telephoto for such sunset pictures, and you'll be rewarded with an impressively large solar disk. Meter sunsets by reading the middle tones of the sky, about 45 degrees away from the sun. Don't meter the sun itself, or the foreground.

Like other pictures, landscapes need
something significant to catch the eye,
such as a figure, a prominent physical
feature, a condition of light, or a splash
of color. You can point to the center of
interest in many ways. Draw the eye to it
by location, according to the rule of
thirds (p 12). Or attract attention to a fig-
ure by using leading lines in the land-
scape. To focus interest on a building,
use the downward slope of a mountain,

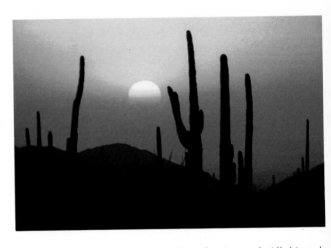

or the winding of a stream. Let light work
for you: Feature a low sun shining
through a grove of trees or on a patch
of grass.

Color contrasts are simple to use. A
tree in fall foliage, the red roof of a
house, a flowering field, or a white horse
in a meadow — all attract the eye.

**● *Foregrounds in sun-
set pictures are usu-
ally silhouetted. But if
you want to see de-
tail there, and the
foreground object is
close enough, you
can light it up with
flash. The effect is
exotic. (Use the right
f-stop for flash-to-
foreground distance,
and adjust your shut-
ter — at sync speed or
slower — to expose
for the sky.)***

Sunsets

Compose a sunset scene as carefully as
any other. Silhouette foreground ob-
jects — trees, rocks, a human figure — as
contrast to the colorful background. For
a good shot, choose the view well in

You can often improve a landscape by putting people in it. Notice how this photographer placed the horse and rider according to the rule of thirds in composition. If a spot of color marks your center of interest, take care that other colors—fall foliage, for example—do not compete with it. When you add people to your scene, have them look at the landscape, not the camera.

advance. Then watch the changing colors. Shoot when they are brightest, usually at or just after sunset.

Bracket your exposures: Take pictures $\frac{1}{2}$ or 1 stop both over and under what your meter indicates. Bracketing guarantees that you will be able to print the best of your exposures.

Don't be so transfixed by the setting sun that you forget to look at the landscape to either side. Light changes rapidly as sunset approaches. Its color warms up. It slants, lengthens shadows, and bathes the scene in orange, then pink, then—as the sun sinks—deep

Low afternoon light throws shadows that outline the contours of an Australian sand dune. Be on the lookout for abstract patterns in landscapes. When you find them, choose your lighting and viewpoint carefully. Low light shows texture. Use a downward camera angle to raise or eliminate the horizon.

● *For backlighted land-scapes, use a lens shade or your hand to screen out internal reflections—lens flare—from the sun. Hold your hand where it will cast a shadow on the lens. Look through an SLR's viewfinder, and you'll see flare disappear when your hand is in the right place.*

This Oregon coast scene proves that you shouldn't hesitate to put the sun in your picture. Do not, however, look straight at the sun's image itself.

● *When you're shooting into the sun, make sure your lens is perfectly clean, and consider taking off your filter. Otherwise the strong light may wash out your picture, an effect similar to driving into the sunset with a dirty windshield. Filters, even clean ones, add one more layer of glass to catch reflections.*

purple. The sidelighting of low sun brings out the texture of terrain or the rough face of a cliff.

Camera Techniques

With different lenses, you can "see" the same scenic view in different ways. But remember that most lenses do not change perspective. Only a change of viewpoint does that. A wide-angle lens will include more of a scene, and a tele-photo can eliminate foreground.

With a wide-angle lens, focus on the spot you wish to feature, and the rest usually will be in focus as well, because these lenses have great depth of field. With a telephoto lens, focus more carefully. Telephotos can emphasize the scenery behind your center of interest—person, animal, or building—by pulling in the background.

Experiment with films. Under some conditions Kodachrome casts a warm

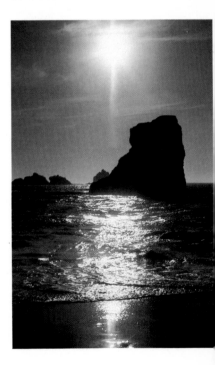

Filters help, when you're shooting black and white. A lens without a filter whitewashes the sky (upper). A light orange filter creates drama by deepening the blue sky (lower) and revealing the clouds. Use a red filter for a spectacularly dark sky, or yellow if you want the scene to look most natural.

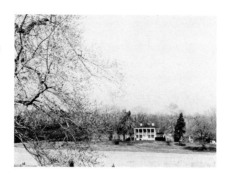

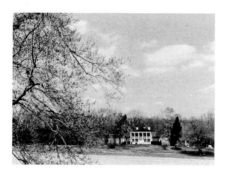

Warning: Never look directly at a bright sun through the viewfinder of your camera. You will damage your eyes.

glow while Kodak Ektachrome lends the scene a bluish tint. Slow-speed film gives the sharpest detail.

To meter a landscape, find an intermediate exposure by taking a reading of a middle tone in the scene. Or, meter both light and dark areas and average. Take care not to meter the sky, unless you want to show the clouds at the cost of underexposing the land below.

Used with black and white film, red, yellow, or orange filters highlight clouds by darkening the sky. You can intensify color and not change its hue with a polarizing filter.

If you are a special effects fan, a whole new world awaits. Filters come in many colors. Other attachments can give you pictures with multiple images, a split field, or starbursts of light (see pp 44-48). You can combine some of these devices to create your own unique, out-of-this-world landscapes.

Nature

Photography of nature has grown with an awareness of our environment. Your picture-making can expand to include off-trail scenery, birds, animals, and close-ups of flowers and insects.

Off the Trail

These pictures are different from the scenic views you snap by the roadside or from a convenient overlook, because you're on your own to find very specific features: What rock formations, vegetation, or bodies of water typify the area? In a forest, move in on a cluster of mushrooms in their old-log habitat. Near the seashore, wait for birds and animals foraging at low tide.

Wildlife

Wildlife photography need not mean a trip to Kenya to shoot lions or giraffes. National parks and wildlife refuges, woods, fields, marshes, and your own

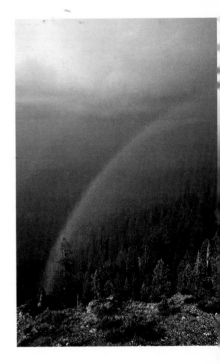

Be ready to catch fleeting effects, such as this rainbow arcing over Klamath National Forest. Meter the sky 45 degrees above the horizon, or (with ISO 100 film) try $1/_{250}$ at f8 if the rainbow is against the blue sky. Against a dark background as here, try $1/_{125}$ at f8. Always bracket. A polarizing filter can add color and definition to the rainbow.

To record a burst of sunbeams, position yourself so that the sun barely peeks from behind a tree or branch. Meter toward the light—but not directly at the sun.

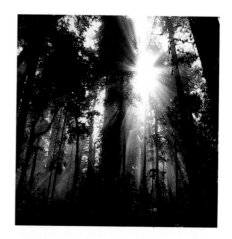

Normally you should avoid centering a horizon. But when you find calm water mirroring a scene such as this fortress-like rock, an evenly divided composition will reinforce the symmetry and serenity of the reflection.

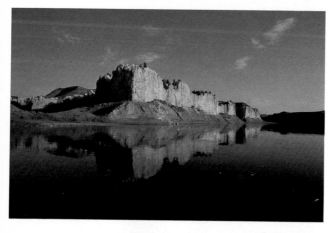

A slow shutter speed of $^{1}/_{8}$ blurs water cascading over a bathing backpacker in Escalante Canyon, Utah. Blurring conveys the water's fluid motion; a stop-action shot would catch the droplets in mid-splash. Try such pictures both ways.

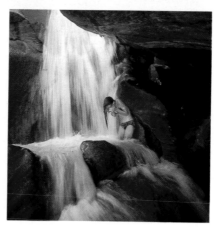

● *Do not think it un-sporting to use your car as a blind. Sit still with the motor off and a telephoto lens braced on the frame of the open window (see p 39). Animals often will ignore the car, and you can shoot as much as you please. But before you can step out they will flee. Three of the four pictures you see here were taken from cars (and the fourth, of the cardinal, from a living room window).*

backyard abound in opportunities. You have the best chance for pictures just after sunup or before sunset. The light is pleasing then, and most animals are out, moving around and feeding.

If you do some background reading on the behavior and habitat of the animals you're interested in, you'll know when and where to look for them.

Keep your camera handy along the trail so you can respond quickly. An easily portable medium telephoto lens, 135mm or so, is a good choice for this kind of photography. Also good is an 80→200mm zoom lens, especially one with a macro setting. But don't be afraid to use normal or wide-angle lenses as well. Keep your camera loaded with high-speed color film so you can shoot in dim light.

If you come upon wild animals, stop and relax. Hasty movement will scare away any animal. If you need to move

A telephoto set at a moderately wide aperture, f5.6, reduced the depth of field to make this snowshoe hare stand out against the blurred foliage.

The photographer made this close-up portrait of a Montana bighorn with a 400mm telephoto lens. Even at the fast shutter speed he used, $1/250$, such a long lens requires firm support.

This picture proves you don't necessarily need a long telephoto lens to photograph wildlife. An 85mm caught this egret in a Florida swamp. Even with a normal lens you can make excellent habitat pictures of wildlife, if you keep the composition as simple as it is here.

closer, do not head straight toward your quarry, but edge in from the side patiently, quietly, and cautiously.

To photograph birds feeding in a tree or bush, approach with a companion. The birds will fly away. In a moment, have your companion leave. Most birds, seeing only that danger has come and gone, will return.

Game animals blend into the landscape, so be careful about the background. Wait to shoot until the deer has stepped out from the shade of a tree and is outlined against the sky or a distant light-colored field.

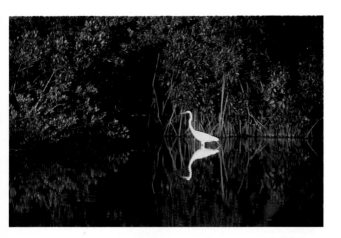

To photograph songbirds from inside your house, set up a feeder near a window, close to a bush or tree branch if possible. Cover the window with something opaque to form a blind. Leave an opening for your lens. Birds will often perch on a handy branch as they approach a feeder, and offer you a natural setting for a picture.

● *It's true; you can take close-ups even with an inexpensive 110 camera. To prove it, tape a pocket magnifying glass over the lens of the camera. First shoot a test roll. With a ruler, increase the lens-to-subject distance slightly for each shot (upper), and keep a record. The results will tell you what distance produced the best focus. From then on, use the ruler to place your camera just that distance away. You will get soft but acceptable close-ups (lower).*

Close-ups

The handiest lens for close-ups of flowers and insects is a macro.

Focus is critical. The closer your camera gets to a subject, the shallower the depth of field. A reduced aperture—f8 or smaller—helps keep the subject sharp. But you must also line up the subject's main features so that they're in the same plane of focus: Keep the plane of the subject and the back of your camera as close to parallel as possible. For example, if you're shooting a flower, tilt the camera body so it is in the same plane as the angle of the blossom. For a butterfly or other insect, focus on the wings or the side of the body and find the right tilt so that most of the subject is in focus before you stop down to a smaller lens opening for added sharpness. At slow shutter speeds, you must firmly brace the camera or mount it on a tripod.

At close range the slightest movement can put your subject out of focus. Early or late in the day is the best time to shoot vegetation because the low sun provides good sidelighting and the wind is stillest then. Use your jacket or another buffer to shelter a flower from breezes during slow exposures. If you must shoot at midday, shade the bloom by holding something over it, and expose for open shade.

You can tinker with the background—remove a distracting twig, or arrange a

A 55mm macro or close-focusing lens brings out the texture and pattern of this leopard frog's skin. The best time to photograph frogs and other amphibians is early in the morning, when they are still sluggish from the chill of night.

If you can't force yourself to get up early—as a nature photographer should—you can still make your flower or fern look as if dawn light were striking it, by using a flash covered with a light-yellow filter. Shoot in deep shade or at dusk, holding your flash to light your subject from the side.

log or some large leaves. Shoot when dew is on the blossom. (Some tricksters spray it with an atomizer, but the effect is not very realistic.) Delicate grasses and seeds can make impressive compositions backlighted against the sky.

If you use flash, bounce it off a white card or a crinkled piece of aluminum foil mounted on cardboard. Take your time and set up for these pictures properly. Don't expect to shoot and run.

When using a flash for close-ups of insects like this mantid, put the flash (off-camera) at a distance that will let you stop down for greatest depth of field. If you haven't the time a professional must spend working with active insects, slow them down by putting them in the refrigerator for a few minutes.

For close-ups of flowers—glacier lilies in this case—sidelight the blossoms and leave the background in deep shade. Expose for the flower only; that way you'll get a nearly black underexposed background.

No shade? Make your own by asking a friend to hold an umbrella or coat over the ground behind your flower. Another good background is the sky. Adjust your exposure for backlighting and shoot the flower from a low angle.

Night Photography

If you go out only in the daytime, you miss half the fun. Night city scenes, floodlighted monuments, and moonlit landscapes await your camera. At night, many different exposures give good results.

Most of these exposures, however, are long. Use a tripod and, at speeds slower than one second, a cable release, so you can hold the shutter open on B without jarring the camera.

You will get the best city scenes in the hour after sunset. Then, city lights are on, but enough daylight remains to show detail and soften harsh contrasts. Use high-speed daylight color film. It will intensify warm city lights and enrich the blue of the night sky.

Daylight color film will often produce the best results on illuminated monuments. But use type B (tungsten) or type A (photoflood) film if you want accurate color slides. Buildings like the U. S. Capitol are faced with marble which—when lighted at night—appears reddish on daylight color film. Type B or type A will give the marble more white.

For exact exposure settings, move close enough to meter only the lighted subject. Don't let spotlights shine into the lens.

● *For shots at dusk, an artist's trick helps to tell when daylight and city lights are photographically balanced. Squint so that you can see form but not detail. When daylight has faded to the point that you can discern only lights and the building outlines against the sky, it's time to shoot.*

● *One simple way to light a nearby subject at night: Turn your car lights on it. Use high beams and make sure the light hits everything you want in the picture.*

Light levels at night are hard to predict. Start with these exposures or comparable settings, then bracket. Use camera support at slow shutter speeds.

Night Exposures

Subject	ISO 64-100		ISO 125-200		ISO 250-400	
Brightly lighted streets	$^1/_{30}$	f2	$^1/_{30}$	f2.8	$^1/_{30}$	f4
Neon signs	$^1/_{60}$	f2.8	$^1/_{60}$	f4	$^1/_{60}$	f5.6
Floodlighted buildings	$^1/_2$	f2.8	$^1/_2$	f4	$^1/_2$	f5.6
Fairs, amusement parks	$^1/_8$	f2.8	$^1/_{15}$	f2.8	$^1/_{15}$	f4
City skylines— Right after sunset At night	$^1/_{60}$ 2 sec.	f2.8 f2	$^1/_{60}$ 2 sec.	f4 f2.8	$^1/_{60}$ 1 sec.	f5.6 f2.8
Landscapes lighted by full moon	4 min.	f4	2 min.	f4	30 sec.	f2.8
	If moonlight is on sand or snow, cut exposure time in half.					

To photograph a dusk cityscape such as this one in San Diego, choose your view in the afternoon. Set up a tripod and wait for the light you like. Bracket your exposures.

The top of Caesar's Palace provided a good vantage point for a shot of the Las Vegas strip. For similar nighttime cityscapes, stop down one or two stops below the meter reading.

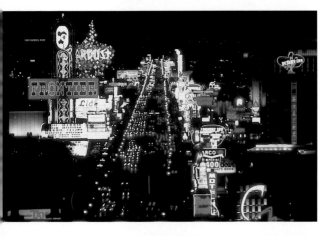

The rich royal blue of the dusk sky rewards the photographer who does not wait for complete darkness. Evenly distributed artificial light, like these brilliant floodlights on the Mormon Temple in Salt Lake City, make monuments easy subjects at night. Dusk provides enough light for the film to pick up elements (like the bench along the sidewalk) that may be lost after dark.

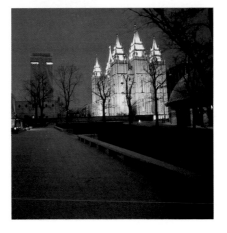

Fairs and Fireworks

At carnivals and amusement parks, try for pattern shots of the neon-lit rides and other moving attractions. Compose the scene while focusing on the lights, and stop the lens down to f16. Leave the shutter open for two to four seconds and let the lights paint the picture.

With ISO 400 film, you can make candid shots under the bright lights. If the meter calls for a shutter speed a bit too slow for a hand-held camera, shoot the roll at ISO 800 and have the film push-processed (see p 23).

To get spectacular fireworks pictures,

You can shoot brightly lit neon signs with a hand-held camera. Use a wide aperture and bracket shutter speeds. Or throw such colored lights out of focus to get a moody abstract pattern.

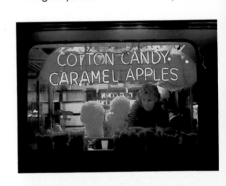

The lights of a carnival or a theme park offer plenty of dazzling color. Try very slow shutter speeds on the moving rides. Here a Disneyland ride and a fireworks show paint motion onto the film in a time exposure.

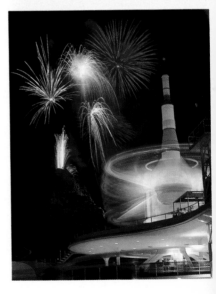

use a tripod. Set the shutter on B and the aperture at f8 for slow film, f11 for ISO 125-200 film, and f16 for ISO 400 or faster. Wait for an explosion, and open the shutter with a cable release. Expose 10 to 30 seconds. Between bursts cover the lens with your hand or a hat, but don't touch the camera.

To photograph lightning with city lights nearby, leave the shutter open about five seconds; for distant city lights about 20 seconds. If there's a long interval between flashes, as well as bright lights or a twilight sky, stop down to f16 on fast film, f11 on slow.

Fireworks blossom over the Washington, D. C. skyline, in counterpoint to the straining figures of the Iwo Jima Memorial. For fireworks, use a medium-length telephoto lens and choose a foreground object to give the scene depth.

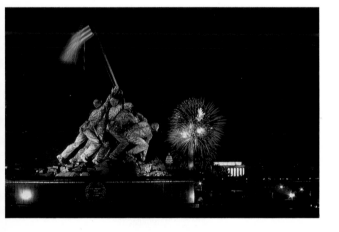

Lightning silhouettes Chimney Rock against a Nebraska sky. For lightning at night, set your camera on B and the lens opening on f5.6 if you're using ISO 50-64 film, on f8 to f11 for ISO 100-200. Focus on infinity. With the camera on a rigid support, frame the area of the sky where lightning has been flashing. Leave the shutter open through several displays, then close it.

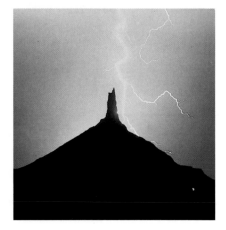

89

Moons and Moonlight

The best times for moon scenes are the first couple of nights of the full moon, just after it rises. Meter at dusk, when the difference in brightness between the moon and the landscape beneath it is not too great. Then bracket.

For the moon to look any larger than a small white spot, you'll need a telephoto—a very long one if you want any surface detail. (For a picture of the moon just by itself, try shooting through a simple telescope. Adapter rings are available for most 35mm cameras.)

Expose a full moon as you would any sunlit scene (after all, it *is* sunlit, isn't it?), $1/_{250}$ at f8 on ISO 64 film, for example. For a half moon, lengthen the exposure to $1/_{60}$, and for a crescent, with the same film, open up one f-stop with an exposure of $1/_{15}$. Bracket exposures.

If you want to take a moon with a city scene at night rather than dusk, make a

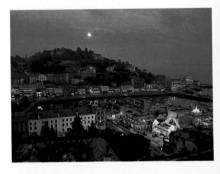

The photographer underexposed the lights of Torquay, England, so as not to overexpose the moon. When you photograph such a scene, you must use a shutter speed fast enough to keep the moon round. Because the moon moves while you're taking its picture, an exposure longer than a few seconds "stretches" it.

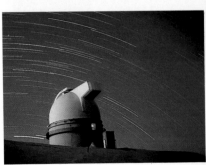

Mauna Kea Observatory looms against the rotating night sky in a one-hour exposure. Star trails need fast film. For circular trails aim toward the North Star. With a wide-open f-stop, expose the film from 15 minutes to 4 hours. You'll get the best results on a moonless sky away from city lights.

double exposure (see p 100).

A landscape in full moonlight may require an exposure of several minutes. When the landscape is backlighted, with the moon above and in front of the camera, you'll get more depth in your picture if you can find a reflective surface—such as snow or water—for the foreground. Don't try to take a moonlit landscape with the moon *in* the picture; the moon will overexpose badly.

The wet, shiny streets of New York's Times Square after a rainfall reflect bright lights to create vivid patterns of color. Rainy weather makes happy hunting for the after-hours photographer. Use a fast lens and a fast film.

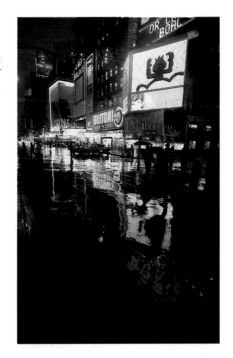

A time exposure transforms highway traffic in Lewiston, Idaho, into a loop of bright streaks. Photographing moving cars is one way to liven up night shots. Leave the shutter open long enough for the cars to move all the way through the scene.

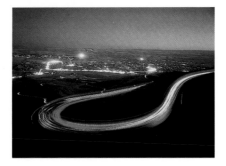

People and Portraits

The ease with which one can capture a photographic likeness seems magical. With a camera you can compete with the master portrait painters. But the results depend on many factors. Some of them you can set up, others you can turn to your advantage.

Individual Portraits

With small film sizes and home lighting, you won't duplicate the work of the professional studio portrait photographer. But with similar techniques, you can come closer than you might think.

Study your subject. A telling portrait reflects personality. If you do not already know your subject, get acquainted in a relaxed atmosphere.

While chatting, move around to observe facial expressions from different angles. Faces are not symmetrical. Anyone may have a "good" side, which a carefully chosen camera position and

● To get the soft-yet-sharp look of a professional portrait, open your telephoto lens to about f4. (With a normal lens, f2 or f2.8 will give similar results.) Focus carefully on the iris of your subject's closest eye — a peculiarity of portraiture is that if the eyes are sharp, the rest of the image will appear sharp.

You can light your portrait from a single source such as a window, as in this case, or a flash. Either way, the results will be better if you bounce the light off a reflector to fill in the shadow side of the face. A large white card mounted on a simple stand, or crinkled aluminum foil pasted on cardboard will do as a reflector. Place it close to your subject — but out of the picture. Move it back and forth, and study the effect.

effective lighting can enhance.

Usually the best camera position is at eye level. From this viewpoint you can ask your subject to turn to the right or left, or tilt his face up or down, depending on the most photogenic angle.

The quality of light is paramount. Soft, indirect light is best. It models features without unpleasant contrast between highlights and shadows. You will find soft light on sunny days in open shade, on misty and overcast days, and indoors near a window away from direct sunlight. You can lighten shadows by reflecting existing light (or flash) off a wall, ceiling, or an improvised reflector.

Flash can also be useful as the main light source or as supplement to window light. Indoors, for diffused light, bounce it off reflectors or white walls.

A medium telephoto lens (85, 105, or 135mm) is the most useful for portraits. With it, you can shoot at a comfortable

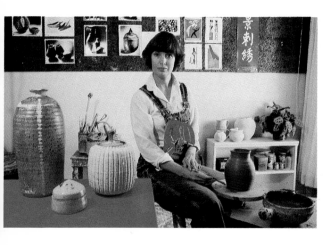

For an environmental portrait of a potter in her studio, a blue photoflood (for daylight film) off to the left supplements the stronger window light and provides soft fill. Photo stores carry these bulbs. Screw them into any lamp socket and move the lamp in and out to vary the amount of fill. When making environmental portraits, use your viewfinder like a sketchpad to add or subtract props.

If you plan to leave part of someone's arms or legs out of the picture, it's best to crop between the joints — at shin, thigh, or mid-forearm — not at the knee or elbow, ankle or wrist. Limbs cropped at the joints may look amputated.

distance from the subject and still obtain a large image with a pleasing perspective on the features. If you do not have a telephoto, pose your subject so the arms, head, and shoulders all are in a plane parallel to the back of the camera. This helps to minimize distortion.

Environmental portraits show people posed in the midst of characteristic activities. This is different from taking candids because here your subject is actively cooperating with you.

Assess the lighting on the scene and decide how you will use it to best advantage. Ask your model to face the light source. Perhaps sidelighting will look better. Add flash if you need to. Or, if you are really ambitious, set up flood lamps.

Pose an artist at work in a studio; a writer at a desk or with books; a craftsman with tools; a cook in the kitchen. Take a gardener into the yard and a swimmer to the pool.

Let your subject work in a normal manner. When he or she is most engrossed, you will get some of your best shots. Keep moving around to get clear views of the face. Every so often, ask your model to look up from the task — then shoot. You want a variety of poses and expressions to choose from.

Outdoors, try to pose your subject in open shade. Beware of bright sunlight. When used directly it causes squinty eyes and harsh shadows. A 105mm telephoto, called a portrait lens, made this informal picture.

How to get your sub-jects to relax, to lose the stiff pose and self-conscious look? For one thing, don't make someone stand for a portrait; have the person sit, sprawl, or lean on something. If the pic-ture is of two people, ask them to tell sto-ries to each other, like "your most em-barrassing moment."

For a group, tell everyone to say "cheese" — really! — or ask them all to stick out their tongues. Snap the picture as they do it, then snap again while every-one's laughing.

Groups

For group portraits, take special care that lighting falls evenly on all the peo-ple. Outdoors in bright sunlight, watch for shadows that may obscure some faces. Arrange your subjects so that the sun shines from the right or left of the camera. If people in back are shaded, move them into the light. Or have the group turn their backs to the sun and in-crease the exposure to accommodate the backlighting. You can move in close to take a meter reading of the faces, then move back to your camera position, and shoot with the close-up reading.

An overcast day or open shade will provide the evenly diffused light that is best for photographing people. You can use a skylight filter to reduce the bluish cast of this kind of light.

For the best indoor portraits, do not aim the flash directly at your subjects. Aim it toward the ceiling if the ceiling is white and not too low. Such indirect lighting resembles diffused outdoor light and will give equally bright illumi-nation from the front to the back of the group. For a similar effect, you can at-tach various reflectors to the flash, or improvise by bouncing it off white card-board or a white cloth.

Group portraits need not be static poses. Look for, or create, action. By prefocusing and stopping down, the photographer was able to catch these exuberant young peo-ple at a folk festival.

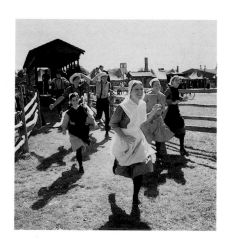

If you cannot take your flash off the camera, stand on a stool or ladder. The height distributes the flash evenly over the group, particularly if the people in front sit and thus stay the same distance from the flash as those in back.

Try arranging your subjects around a central figure or activity, depending on the mood you want to create or the story you want to tell. If possible, set your group against a background that reveals something about them.

Keep in mind that faces have to be recognizable. This means you should move in with the camera. Keep the subjects close together to get the largest possible image size.

In the traditional "classroom" shot, the first row sits or kneels; the second stands — an arrangement that keeps the faces together. Or you can line up people on a staircase. That will achieve the same result.

To vary the stacked pose, arrange the group around one person who is the center of interest. A grandparent, grandchild or a just-married couple are possible main subjects for a family pose. The boss, the captain of the team, or the trophy winner could be focal points in other groups.

Arrange your subjects carefully. By joining these three West Virginia sisters in a triangular composition, the photographer subtly suggests their kinship. The sisters' direct gaze out of the frame unifies them and links them to the viewer. Arrange your group shots so that everyone is looking at the same thing — either the camera or someone or something in their midst.

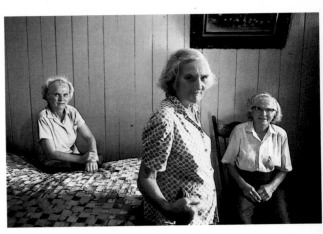

● *Beware of blinking eyes. Whenever you do a portrait, particularly if it's of several people, make more than one exposure. You never know when flicking eyelids may make one of your subjects — and your photograph — look sound asleep.*

You can place your center of attraction in the foreground, and ask the others to talk to him or smile at him. But the principal person need not be in the center of the picture. To make a strong composition, place the most important figure a little to one side, with the group's attention focused there.

A wide-angle lens is a good tool for group shots because it helps you get every person in the picture when you haven't much room to maneuver.

In any group arrangement, for maximum sharpness throughout the picture, focus on a point about one-third of the way from the nearest to the farthest person. Check your depth-of-field scale, especially if the light is dim.

To shoot a group in motion, first arrange them as you want them for the picture. Mark your reference point and focus on it. Stop the lens down enough to make the entire group sharp. Then back up your subjects, and ask them to walk, run, or ride toward you. When they reach your reference point, shoot.

Have fun with groups. Create new picture ideas — such as posing the family on a ladder under the family tree, or viewing the basketball team through the hoop. Use your imagination.

In this informal group portrait, a Vermont auctioneer creates a center of interest with a toothy display of the cow he's selling. Local farmers join in his amusement. If all had looked at the cow instead of the camera, the picture would have been different but equally successful.

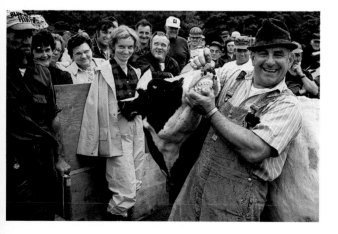

Pets

In pet photography, get close, get low, and keep the background simple.

Playtime is a good time to have your camera ready. When the puppy grabs the slipper or chases the ball, you can get quick flash action. Ask a friend to help by dangling a ball of yarn for the kitten or attracting the dog's attention. People and pets together make appealing portraits.

An animal's eyes, ears, and posture convey feeling just as human faces and movements do. A whistle gives you the alert ears-up expression — but mournful ears-down can make a good picture too.

For pet portraits, you need patience and quick reflexes. It also helps to know your pet's personality. Record a favorite expression in a close-up.

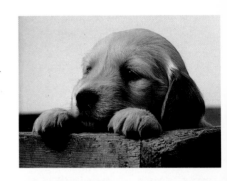

Get down to pet's-eye level for pictures of a romp through the grass. Lie flat on your stomach with elbows apart for stability. Anticipate the pet's path. Prefocus and preset your camera. Release the shutter as your pet runs toward you.

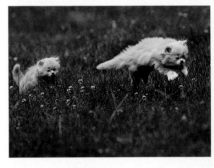

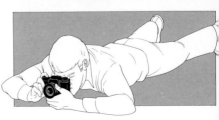

Special Situations

Aerial Photography

Whether you're in an airliner or a small plane, prepare before you go up. In a small plane or helicopter, ask if you can raise or remove the window. If not, you can still take good pictures provided the windows are clean and you shoot on the side away from the sun. When you must shoot through a closed window, use a wide f-stop and hold the lens about an inch from the pane.

Load your camera before you board, and carry extra film. Slower films are best because their fine grain will hold the small detail of the view.

Focus on infinity. Secure the focusing ring on the lens with a piece of tape so it won't shift accidentally. Set your shutter speed on $^{1}/_{250}$ for the average aerial shot. If you are below 1,000 feet, if the air is bumpy, or if there is excessive vibration, then use the fastest shutter speed you have. Adjust the f-stop for the best exposure. Don't brace yourself or your camera against the plane; you'll pick up engine vibrations.

Watch how light plays on the scene below. Low light brings out the most detail. Choose something to add pictorial interest—a cluster of buildings or the pattern of highways or plowed fields.

● *On airliners try for a seat on the shady side in front of the wing. You can include the wing in your picture or not, as you wish. You'll get some of your best shots just after take-off and before landing. Near the ground, pan with your subject at $^{1}/_{500}$ or faster.*

Hedgerows etch a landscape in Devon, England. Look for such patterns in aerial photography, as well as for a center of interest like the rainbow. Use a skylight filter or a polarizer to reduce haze and improve color. (Don't, however, use polarizers through Plexiglas windows.)

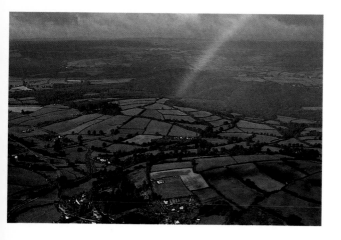

Double Exposures

Two or more images on the same frame can make an eye-catching picture. The results may be subtle—a giant moon over a cityscape often looks like a single exposure—or eerie, such as a ghostly figure floating across a room. Try multiple exposures: Three or four neon signs on one frame may suggest the kaleidoscopic liveliness of a night-club district. Since the mechanics of making multiple exposures vary from camera to camera, consult your instruction manual.

Superimpose your images so that one does not interfere with the other. Make sure your close-up of an eye peering over a mountain range, for example, does not overlap one of the mountains. Unless one of your images is on a black background (like a full moon at night), slightly underexpose each shot so that you won't overexpose the entire frame.

For a double exposure of the full moon over an illuminated monument or any other night city scene, shoot the moon in a clear, dark sky with a strong telephoto. Position the moon in the upper corner of the frame. Then, without advancing the film, use a wide-angle lens to photograph the cityscape.

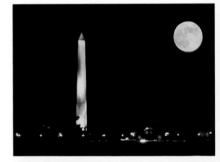

To double up images outside the camera, take two slides from their mounts and combine them in one. (Camera stores sell spare mounts.) Here, one slide in the "sandwich" shows the sun over a wildlife refuge, and the other the geese. An overexposed sky left the second slide clear except for the birds.

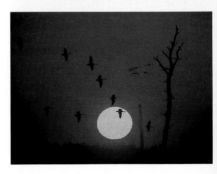

Shows on television screens require a shutter speed no faster than $^1/_{30}$. (At shorter speeds, some shutters will not register the whole TV image.) Meter for the correct f-stop. For color television, use daylight color film and redden the TV picture slightly with the set's tint control.

Show and Theater Shooting

Do not use flash to photograph night sports or stage performances from your seat. The light will not carry, and you will disturb both audience and performers. Use Kodacolor 400 or Type B Professional Kodak Ektachrome 160 film, pushed to ISO 320 (see p 23).

Lighting varies greatly at any staged performance. For this reason, exposures are impossible to predict. It will be hard to focus on moving performers, so focus first on a spot on stage and shoot when the action reaches that place. The curtain call is a sure thing. Then the lights are on full, and you will get the entire troupe.

Some productions prohibit photography, but you may be able to obtain special permission. If you can, see the show through once to make plans, and then go back to take pictures. And don't forget the action backstage.

Yellow stage lighting illuminates performing musicians. Such colored lights, often dimmer than white ones, demand fast film and fast lenses as well. A medium telephoto with a large maximum aperture is ideal for these performances because it's easy to focus in low light. Try an f1.8 85mm lens, or 105mm that can open up to f2.5.

● *When you're taking pictures on a rainy day, carry an umbrella — and use it. Water will damage your flash, and you may receive an electric shock. Bad weather requires special precautions for your equipment. See pages 114-116 for some pointers.*

Snow, Rain, and Stormy Skies

Wild weather drives an imaginative photographer outdoors. A brooding, stormy sky can enhance or dramatize your picture. Fast-moving clouds and shafts of sunlight alter a landscape from one moment to the next.

You can photograph falling rain most easily against a dark background and with a fast shutter speed — at least $^{1}/_{125}$. Use slower speeds if you want to turn the rain into streaks.

You will probably find the most picturesque cold weather scenes right after a snowfall, when tree branches are white

Snow and ice scenes tend to underexpose (upper) because the bright white makes the meter read too high. Take your exposure reading from a middle-toned area such as the 18-percent gray card on the inside back cover, or from the palm of your hand. Use that reading for a truly snow-white picture (lower). If it's an important shot, bracket a stop or two in both directions.

and heavy, and no skiers or hikers have yet disturbed the landscape. Then you can make the monochromatic pictures which express so well the mood of cold and peaceful isolation.

A snowy day will also bring an opportunity to take bright, active shots. Include people in colorful winter clothing.

For close-ups of frosty fences or foliage, as well as small areas of snowscape, use sidelighting to bring out detail and texture.

You can photograph streaks of falling snow with a slow shutter speed (up to one second). You'll get best results with

Look for touches of color on a rainy day. Bright slickers make these boaters stand out against the gray, rain-spattered water around them. Keep an eye out for the circular patterns that raindrops form on water.

Soft pinks and blues dominate the light after a storm over Lake Superior, as waves batter the shoreline. Careful timing caught the lighthouse's beacon as it revolved. To play up contrasts in turbulent weather, expose for highlights such as the whitecaps here, so that the areas in shadow stay dark.

sidelighting against a dark background. Don't use flash in falling snow. The light bounces right back off the closest flakes and shows nothing else.

Underwater Photography

Serious underwater photographers own special cameras, but you can begin with inexpensive gear and homemade devices. For shallow-water pictures, saw the bottom off a plastic glass and glue a UV or skylight filter in its place. (Use epoxy or aquarium glue.) Hold the glass over your camera lens and lower the bottom of the glass an inch or so below the surface of the water. Shoot through the filter.

For deeper water, you can buy an underwater housing: a tough plastic bag with a clear glass filter and built-in plastic gloves. Your camera goes inside the bag. You can also buy special housings for 110 and 35mm cameras.

Try to work at midday, when the sun is overhead and at its brightest. As you descend, light dims. If your camera does not determine exposure automatically, increase exposure from your daylight reading about one stop for each 10 feet of depth. You must work close to your subject — usually within 10 feet.

A Weathermatic by Minolta (upper) photographs down to 15 feet. The more expensive Nikonos (lower) is watertight to 160 feet.

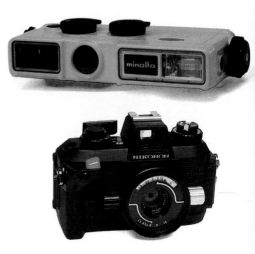

Because water bends light rays, objects seem to be about 25 percent closer than they actually are. Focus for the apparent distance, not the real one. With an SLR that lets you focus through the viewfinder, you can do this easily. Otherwise, set the focus for three-fourths the real distance. The distortion also restricts the angle of view. A 35mm lens underwater takes in only as much as a 50mm lens on dry land.

As you dive deeper, blues predominate over reds. To compensate, screw on a 30 CC red filter. Use flash only if it's designed for underwater work.

For underwater shots from the surface, put your lens against the glass faceplate of a diving mask, and barely submerge the faceplate. (Try this only in calm water.) Alternatively, put the camera in a small, dry aquarium, lens against the glass. Set the self-timer, push the aquarium part-way into the water, and wait for the shutter to click.

A camera above water hooked a trout (right); a reef requires snorkel and underwater gear.

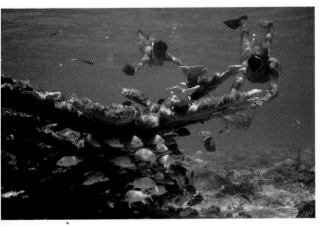

Travel Photography

Travel photos can be precious reminders of "having a wonderful time," and a recurring pleasure for years. You can put together albums and slide shows or, if you're so inclined and your pictures are good enough, venture into the freelance market. Here's how you can come back with pictures you're proud of.

Getting Ready

● **What to shoot? Don't hesitate to look at local postcards; then go shoot the scene your way. Take a city tour for orientation, then go back later on to the places you liked, when you have more time to shoot and the light may be better. Check papers and posters for any events not especially planned for tourists.**

Backlighted smoke of "Brown Bess" muskets floats over this Colonial Williamsburg re-enactment. The bright cloud makes the photo a meter cheater (p 29); take your reading from a medium-tone object.

Taking pictures on a trip is not like taking snapshots around your hometown. Much is unfamiliar and unexpected, especially abroad. You may not be able to find—or afford—the film you want, or get your camera repaired, or reshoot a scene you missed the first time.

So, if you want to return with images instead of alibis, take time to plan your photography, just as you plan your itinerary and your travel wardrobe. To add to your own ideas, check articles, travel folders, and books on your destination, and draw up a "must shoot" list.

Keep your equipment to the minimum that will handle most situations (see opposite), but include items needed for any special photography you plan on: a close-up lens, a long lens for wildlife, or an underwater housing. Pack it all in a simple gadget bag—not one that says, "I have valuable equipment inside!"

For a pocket-size re-flector that will soften harsh light from your electronic flash, try a gadget called Air-Brella, which you can inflate and attach to your flash unit to pro-vide a reflective white surface for bounce lighting.

You can make good pictures with minimum equipment—but you'll have more fun and get better results with a larger outfit. Modify this list to suit your needs and budget.

Don't buy new equipment, or a new kind of film, on the eve of your depar-ture; take time to test it and familiarize yourself with it. If over a year or two has passed since your camera was cleaned and checked, have that done—but be sure to do it in time to try it out before you leave. Shoot a roll of slide film under various conditions, and examine the re-sults to make sure the repairs worked.

Pack at least one 36-exposure roll of 35mm film (or equivalent for your cam-era) for each day of your trip. Buy the film all at once (sometimes you can get a discount) in 36-shot rolls; shorter rolls

	Checklist for Travel
Cameras	☐ A 35mm SLR with a built-in meter and interchangeable lenses. A second camera body that accepts the same lenses will serve as a spare—important if one camera breaks down in a remote area—and enables you to keep different films and a pair of lenses ready for action.
Lenses	☐ Take several. Some possible combinations: 28, 50, and 105mm; 28, 55 macro, 90, and 180mm; 21, 35, and 80mm; a single 35→85mm zoom; or two zooms, 35→85mm and 80→200mm, one with a macro setting. (This combination gives the widest range with the fewest lenses.)
Filters	☐ Skylight filters, to protect lenses, cut haze, and warm colors in open shade. ☐ A polarizing filter, to deepen sky color and eliminate reflections. ☐ Conversion filters for using daylight film in tungsten light (or vice versa) without a color shift. ☐ A correction filter for fluorescent lighting. ☐ Yellow and red filters for sky contrast—if you're going to shoot in black and white.
Flash	☐ A small tilting-head automatic electronic unit, or any other small flash. (Compactness is worth more than power on the road.) Include a connecting cord so you can hold the flash away from the camera. *Note:* If you are going abroad, rely on batteries, not a re-charger; your unit may not work on overseas voltages.
Accessories	☐ A close-up attachment (if you have no macro lens). ☐ A mini-tripod and cable release. ☐ Extra batteries for your power-hungry flash unit, and a single set of extras for your camera and meter. (Start your trip with fresh batteries installed in everything.) ☐ Lens shades; front and back lens caps for all lenses. ☐ Cleaning brushes for lens and camera, lens cleaning fluid and tissue, and a rubber bulb for blowing dust away. ☐ A set of tiny jeweler's screwdrivers for anything that might vibrate loose. ☐ Notepad and pens.

● **Plan picture stories about your trip. Take "title" shots of signs or maps; "establishing" shots, which show an overview of the city, or resort, or building you're about to enter; and medium-range and close-up shots that tell of the activities there.**

Setting Out

Photograph your friends doing things that travelers do, like asking directions, instead of just standing in front of a famous site. Look for symbols of your location; here, the bobby and the double-decker bus both say, "London."

cost more money, space, and reloading time. You can save space by discarding the cardboard boxes (keeping one copy of the data sheet for each film type). Mark each film can with its contents.

Plan a mix of medium-speed (ISO 64-125) and fast film (ISO 400), according to what you plan to shoot and the kind of lighting you expect. Even on a sunny beach vacation, take a roll or two of fast film for indoor, foul-weather, and night-time shooting.

It's a bad idea to plan on buying film in every foreign port. Brands differ, and you may have trouble finding a lab to process such film back home. Off the beaten track you may not find any film at all. Buy your supply at home. The same holds for flashbulbs and batteries.

In the U. S., the Federal Aviation Agency says, airport X-ray machines used on hand baggage do not fog film. However, you have a legal right to request and receive a visual hand baggage inspection, and it's a good idea to do so, every time. Don't pack film in checked baggage, which may be X-rayed with an even heavier dosage.

Hand-baggage doses abroad may be much higher. There are many confirmed

Shoot not only the scene or action, but people's reactions to it. When you first walk up to the edge of the Grand Canyon, aim the camera at your family; the view will still be there after that look on your kids' faces is gone.

cases of film damage. The effect is worst on fast films, and it is cumulative: one inspection may not cause visible damage, but five will. (Metal detectors, unlike X rays, are harmless.)

So pack exposed and unexposed film in clear zip-shut plastic bags, placed at the top of your carryon case. Check in early; take the film out of the case, and send the case on through the machine. Offer the bags of film to the officer and ask for a visual inspection. Do the same for your camera if there's film in it.

You have no *right* to a visual inspection abroad, but a polite request may be granted. The chances vary from one country and airport to another, and may be better in places with old X-ray equipment than in airports with new machines thought to be harmless. And if authorities insist on X-raying, they may be able to lower the intensity while your film goes through.

In countries with good postal service, airmail film home to avoid accident or airport X rays. Use prepaid processing mailers (buy before you leave!), or mail rolls to a friend. Film mailer envelopes probably won't be X-rayed or charged duty, but boxes or padded envelopes should be marked "Exposed photographic film — No commercial value. Do not X-ray." Mail the film in boxes of six rolls or more.

To avoid duty charges when you return, register your foreign-made equipment with U. S. Customs before you leave, especially if you're taking more than one camera or lens. There are registration offices at international airports. Allow plenty of time, and be sure you can find the serial number on each item.

Busy surroundings reflect the excitement and bustle of Disneyland. Yet the photographer kept the composition simple by lining up a sunlit Dumbo against a shadowed background. Amusement park rides make good action pictures.

- *Don't keep your lens cap on all the time; taking time to remove it may cost you a picture. Do protect your lenses with skylight filters, but remember to remove them when the sun or a bright light is in the picture.*

On the Road

A wide-angle lens frames this Czech couple between the musicians playing for them—a juxtaposition that several photographers in this scene seem not to have thought of. Get in close to the action at lively times like this. Look for subjects in the crowd as well.

The registration form proves you owned the equipment when you left, and may be useful in case of loss or theft abroad.

Most countries let tourists' camera gear in free. If yours attracts attention, explain that you're a tourist and an *amateur* photographer. Show your U. S. Customs registration. At worst, you'll have to reregister your equipment so customs can see that you're taking it out again when you leave. If that happens, allow extra time at your departure.

Travel photography starts at your front door. Luggage-heaped taxis or waiting passengers in an airport make excellent scene-setters. Pictures made of the tour bus or taken from the aircraft window or framed by the car windshield tell more about your trip than they actually show. Photograph your *travels*—not just the places you visit.

Good pictures can turn up anywhere, anytime. Don't fumble or wait for a better moment; get *this* moment, *then* wait. Keep your camera next to you all the time, set at the right exposure and a likely distance, and watch for opportunities: the sleeping child in the next seat, or the old ladies at the market (see Candids, pp 57-59). Don't stand in midsidewalk

● **With your very first shot, adopt the note-taking habit; it's worth it. Use a pocket notebook, a tape cassette, or your travel diary to note the essentials: Where you took each photo and what the subject is. If you wish, add date and technical data — aperture, shutter speed, and lens focal length. For showing photographs to friends afterwards, you can also note "color": How you got the picture, what else was happening at the time, and that this was where you found that great jambalaya.**

peering through the viewfinder; sit on a park bench, stand in a doorway, or shoot from inside your car. Wear clothes that don't stand out in local crowds. Above all, walk around. Explore all you can. Get a little lost. Don't eat at the hotel; scout out other places. Photograph people, signs, your glass of wine on the table, market displays, side streets, a cat dozing in the sun. Look for meaningful details: a dyer's stained fingers, rows of shoes outside a mosque. Bad luck can make good pictures, too; that flat tire will liven up a slide show at home. And when it's too dark, too wet, too hot, or too dusty to keep shooting — then keep on shooting! That's when you'll get your most unusual pictures. Take several shots, bracketing exposures; film is cheaper than another trip.

Photograph people — workers, vendors, people on the street — doing things that are everyday to them, but

Massed azaleas glow on Rome's Spanish Steps, where the raking light of early morning sharply defines shapes and patterns. Try to arrange your travel schedule so you'll be free for picture taking in the low light of morning and late afternoon.

A high camera angle picks out a candle-studded float in a Peruvian Holy Week procession. Always try for night pictures on your trip. Outdoors at long distances, rely on time exposures, not flash, unless you have a powerful unit.

unusual to you. Often they are pleased to be photographed, proud of what they do, and willing to pose for you—or better yet, to go on working. Photographing children is another good way to make friends and get good pictures. Learn a few polite forms in the local language—"please," "thank you," "hello"—and use them, even badly. In most countries your efforts will be appreciated.

Be friendly in a way that suits local customs. You'll find you can communicate, language barrier or no. And if someone firmly objects to being photographed, respect the preference.

Open shade in the Damascus bazaar provides soft light, best for faces. A skylight filter's pale pink will keep skin tones in open shade from looking too blue. City markets are good places to practice your candid photography.

Camera Etiquette Around the World

In North America we can aim our cameras anywhere that tact and courtesy permit. Copyrighted shows and military installations are the only commonly forbidden subjects. But customs and restrictions abroad are different, and vary from country to country. Many nations forbid photographs at airports; others ban shots of what you might consider quaintness and color — but which local officials see as embarrassing poverty.

Posted signs may say that photography is prohibited, but sometimes the bans are informal. Asking a local passerby, even in gestures, can save trouble, and it's an easy way to make a contact that often leads to other pictures. If told to put away your camera, don't get excited and demand your rights. Smile, be reasonable, and if that doesn't work, move on.

Strong leading lines sweep the eye from foreground to horizon, hinting at the length of China's Great Wall. Look for new ways to approach often-photographed sites: A striking camera angle, a close-up, a bad-weather shot, a dusk exposure, a strong telephoto or wide-angle treatment.

Western Europe. Standards and expectations here are similar to those in North America. People are usually willing subjects at festivals and celebrations. Local tourism offices can tell you about good opportunities for pictures.

Eastern Europe. Outside the tourist zones, cameras may be met with official suspicion, but country people especially are often welcoming and pleasant.

● *In wet situations —
boating, swimming,
in the rain — put your
camera in a clear
plastic bag. Use a
tight rubber band to
anchor the open
mouth of the bag
around the end of the
lens, so only your
skylight filter is ex-
posed. The bag
should be loose
enough for you to
manipulate the cam-
era controls through
the plastic. Take
some tissue in an-
other plastic bag for
wiping drops off the
filter. (Don't rely on
this arrangement to
protect your camera
underwater; it's not
strong enough.)*

*Louis XV's crown
draws admirers at the
Louvre in Paris. In
museums, consider
not only the displays,
but also the people
who come to see them.
Museums also offer a
chance to vary your
travel shots with some
close-ups. A polariz-
ing filter will help you
reduce reflections on
display case glass.*

Don't photograph anything of military value (bridges, dams, railroad tunnels).

Middle East. This region may pose problems. Israel is security-conscious. In Muslim countries attitudes toward cameras vary greatly, from Saudi Arabia's preference for no pictures at all to Egypt's open friendliness. Be tactful. Men should not photograph women (although women visitors may). A non-Muslim can often get permission to photograph inside mosques, but this will be easier in countries and at mosques where tourists are common.

Far East. In China, itineraries that must be arranged in advance are not very flexible thereafter. Japan and Hong Kong do not restrict photographers; in the rest of the Far East, expect considerable reserve about photographers outside the big cities.

Latin America, Caribbean. This colorful region is generally very open, its people very friendly. Look for lavishly celebrated church festivals. Mexico's tourist bureau is well organized and has offices throughout the country. Don't photograph slums or beggars, particularly in the Caribbean.

Africa. Many Africans are sensitive about cameras, so ask first. You may

have to tip. Airports, highway intersections, even schools and post offices may be forbidden subjects.

South Pacific. Australia and New Zealand are very open. In the islands, politeness is a key; traditions of respect and veneration still run strong.

Coping With Climate

● *In hot weather, especially in deserts, keep extra film in a foam picnic cooler, and stock it with ice every morning. Wrap ice in one watertight plastic bag, film in another. Give the film an hour to warm up before you open the package. In cold weather, keep extra film warm in an inside pocket.*

Changing weather, on the road or at home, calls for special equipment care.

Cold weakens batteries, thickens lubrication, turns film brittle, and promotes static sparking that marks the image. Take extra batteries, carry your camera under your coat to keep it warm, and advance and rewind film slowly.

Heat can alter film color, warp your lenses, and cause oil leaks. Keep your camera shaded, and never leave it (or film) anywhere in a closed car, where temperatures can quickly reach 120° F.

Cold-to-hot temperature changes: If you're going from air-conditioned cool

A tripod, existing light, and a long exposure combine to contrast the eternal beauty of "Venus de Milo" with the restless motion of her visitors. With a still longer exposure—five seconds or more—you can eliminate the art lovers almost entirely, if they don't stand still long enough to register on the film. Experiment with slow shutter speeds and slow film.

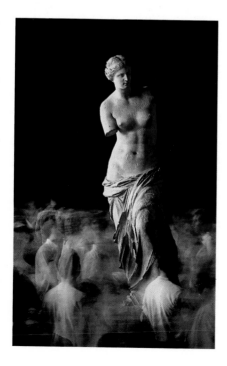

● *Silica gel is an invaluable humidity fighter in damp weather, hot or cold. Seal it in your gadget bag and in boxes of slides, negatives, and prints. Once saturated, silica gel can be dried out in the oven and reused. Unfortunately, silica gel is hard to find in less than bulk quantity. Try scientific supply houses and chemical companies, or ask your camera store if it can be ordered. (Don't use powdery silica gel from hobby stores; the dust may damage your equipment.)*

to outdoor swelter, or from winter chill to central heating, the sudden change will condense moisture on your film and camera parts. Seal the camera in a plastic bag while you're in the cold air, move into the heat, and let the camera warm up before you open the bag.

Rain drops won't hurt your camera if wiped off promptly, but protect it from a downpour under your coat or in a plastic bag, taking it out just to shoot.

Humidity harms film and equipment. Leave cans of unexposed film capped. Store cameras and loose, exposed film sealed up with plenty of silica gel.

Salty air corrodes; avoid changing film or lenses near salt spray.

Dust scratches film and camera innards. Clean your camera every time you open it, with a camel-hair brush or with air from a rubber squeeze bulb. Change lenses and film out of the wind.

Back Home

Editing slides is easy with an inexpensive plastic-and-metal slide sorter. This one folds up for storage. Use your 50mm lens as a magnifying glass.

To prepare a slide show or album of your trip, remember you're telling a story. Organize your pictures around ideas or themes, not necessarily in simple chronological order. Tie in anecdotes with illustrations. Include close-ups of maps and signs. Select a variety of compositions—close-ups and long

To keep your slides right side up and in order for projection, get them all oriented properly, then draw a heavy diagonal line along the stack, on the side that goes up in the projector (upside down on the slide). If a slide is turned over or out of order, you'll see a break in the line.

Don't let your pictures languish in a drawer! Make large color prints (from color or negatives for the best quality) and hang them up.

Contact prints and transparent sheets for negatives help keep black and white or color-print pictures organized. Boxes and loose-leaf plastic sheets do the same for transparencies.

shots, landscapes and people, stills and action. Edit your pictures critically, and throw out all but the best; then select from those to make your show.

Above all, keep the show to a reasonable length; leave your audience wishing for more, not praying for less. Practice your commentary beforehand.

A filing system is essential. File by subject, date, or some other system; keep it simple but make sure it works.

To file black and white negatives, order a contact sheet showing all the exposures on the roll. Put the negatives in strips in a transparent file sheet, put the file in a binder, and file the contact sheet in the binder with the negatives.

Keep color negatives in the lab envelopes, and mark each print you might want to enlarge with the frame number of its negative.

File slides in covered projector trays, in transparent plastic storage pages, or in a box or drawer with separation cards. On the cardboard mounts or on the boxes, write or stamp a film roll number keyed to the numbered pages of your "what-where-when" notebook.

Slides, prints, and negatives left in the sun or strong light will fade. Store them in a cool, dark, dry, dust-free area—not in a hot attic or a damp basement. Negatives and slides in clear protective sheets should be kept in a covered file drawer. Don't keep prints (especially color prints) in plastic bags.

Appendix:

Camera and Film Care

● *What to do if...*

...you can't get your filter off the lens: Press the filter firmly toward the lens with your cupped palm, and twist. If that fails, wrap a piece of rubber around the filter ring and turn. Try a rubber band, the pad on your shoulder strap, or an automobile fan belt. A rubber jar opener may work, too. Don't use pliers.

...you can't rewind your film because it has torn loose from the cassette: In pitch dark, open the camera and find the loose end of the film. Working by touch, hold the film by the edges, wind it tightly, and put it in the light-tight container your film came in. Mark it for the processor: "Special handling. Open in dark!"

...your lens fogs up when you go out into cold air: Just take off the lens and let it sit for 15 or 20 minutes. The lens will clear after it has cooled to the ambient temperature. See p 115 for what to do when you go back inside.

Maintaining Your Camera

Modern cameras can't be repaired without special tools and training, but you can do much to keep yours working right, and to limit your losses if it fails.

First, read your instruction book from cover to cover. Then shoot a test roll of color slides (not prints); vary the conditions; and keep notes: indoors, outdoors, sunlight, shade, flash, every aperture, every shutter speed, various distances. If any slides seem to show a camera failure, take camera and slides to the dealer and ask what went wrong.

Keep all your gear clean. Use a soft cloth on the outside of the camera body and a camel-hair brush—not the same one you use on the lens—to dust the inside, including the focusing screen above the mirror. Never touch the front of the mirror with any object. Instead, use repeated squirts of air from an all-rubber ear syringe (available in drug stores) to blow dust from the mirror and from crevices inside the body and out.

Clean the film guide rails, the pressure plate, and the outside lens of the viewfinder with a cotton swab moistened in lens cleaning fluid. Don't use liquid on plastic focusing screens.

Avoid cleaning the lens unnecessarily. See whether a puff of air will do the job (some lens brushes have a rubber squeeze bulb for the purpose). If not, use a soft brush and check again. If necessary, pleat a piece of lens tissue—*not* silicone tissue for eyeglasses—tear off the end, and put a few drops of lens cleaning fluid on the ragged edge. (Don't drop fluid directly on the lens.) Gently wipe the lens from center to edge, then around the joint between glass and mount. Check whether the back lens element needs cleaning; if it doesn't, don't clean it.

Tighten tiny screws on lenses and body with a jeweler's screwdriver.

If you see dirt particles in sharp focus when you look in an SLR viewfinder, they are on the focusing screen. Out-of-focus particles are on the viewfinder lens, the mirror, or the front or back of the main lens. Clean according to instructions.

Don't leave a range-finder camera with its lens uncapped and aimed upward on a sunny day. Focused sunlight can burn the shutter curtain.

Before you insert fresh batteries, go over the contacts with a clean pencil eraser, then a clean, dry cloth to remove any oxides. (Don't do this to the contacts in your camera or light meter, where eraser crumbs are a risk.) Avoid getting grease or petroleum jelly on the battery contacts.

Keep batteries cool and dry for longest shelf life: in an air-conditioned room, or inside a plastic bag in the refrigerator. Don't freeze them. Let them warm to room temperature before using.

That's a lot cheaper than replacing them after they loosen and fall out.

Store your camera with the shutter uncocked, so that it isn't under tension. Cap the lens. Put the camera in the original box, with its foam padding and its package of silica gel. Remove the batteries from equipment you're not going to use for a few months or longer.

Do-it-yourself Checks

If your pictures show a consistent problem, perform some simple tests. With the camera back open, release the shutter at each speed, while looking through the lens from behind. You can usually see and hear enough difference between the shutter speeds to tell whether everything is in order.

If many — but not all — of your pictures are badly overexposed, your lens may not be stopping down properly. Follow the above procedure with the shutter set at $1/2$. Vary the f-stops to see if the aperture opens and closes. Then hold the shutter open on "B," and run through the aperture settings. The diaphragm should expand and contract smoothly.

Check your meter in different kinds of light to see if the readings it gives are close to the settings suggested by the f16 rule (p 31) or by the film data sheet. (Don't point it directly at bright lights.)

Film Care and Storage

Film keeps best in cold. Buy it fresh and in bulk (it's usually cheaper that way) and store it high in the refrigerator, where things won't spill on it. Cool storage will add a year to the shelf life marked on the box; freezer storage effectively stops aging altogether. Allow time for the film to warm up before you open the can or foil wrapper, or moisture will condense on it: at least one hour at room temperature for refrigerated film, three for frozen film.

About the author: Albert Moldvay, a former National Geographic photographer, brings to this guide the experience of four decades in photography. He is known for his nationally syndicated newspaper column on camera skills. Teacher and lecturer, he is also the author, with Erika Fabian, of a series of photographer's guidebooks on major world cities.

Acknowledgments: Many people helped with this *Field Guide*. Our thanks go to the National Geographic photographers and their free-lance colleagues for the many pictures they contributed . . . to Robert E. Gilka, Bates Littlehales, Joseph J. Scherschel, and Volkmar Wentzel of the Geographic's photographic staff for their advice and comment, as well as to Caroline A. Grimes of the Eastman Kodak Company and Steve Franklin of Industrial Photographic Products, Inc. . . . to the staffs of the Geographic's equipment and processing labs for their technical help . . . and to the staff photographers and others who contributed their tips, techniques, and counsel, especially Roger M. Allen, James L. Amos, James P. Blair, Jim Brandenberg, Bruce Dale, Annie Griffiths, David Alan Harvey, David F. Robinson, Stephen G. St. John, Robert F. Sisson, and Rex A. Stucky.

Type composition by the Typographic section of National Geographic Production Services, Pre-Press Division. Color separations by Accu-Color Group, Inc., New York, N.Y., and The Lanman Progressive Companies, Washington, D. C. Printed and bound by Kingsport Press, Kingsport, Tenn. Paper by Mead Paper Co., New York, N.Y.

Library of Congress ℂℙ Data
Moldvay, Albert, 1921-
National Geographic
photographer's field guide.
1. Photography — Handbooks, manuals, etc.
I. National Geographic Society (U. S.).
II. Title.
TR146.M59 1988 770'.28 88-5269
ISBN 0-87044-754-8

The surface on the inside back cover is a "gray card" that reflects about 18 percent of the light falling on it—the average that your light meter is calibrated for. Use the card when you face a tricky exposure problem (pp 28-31). Hold the card in the same light, and at the same angle to the light, as the subject you want correctly exposed. Meter the card, close enough so that the meter sees only the card, but not so close that you shade the card. (If you're getting glare from the card, change its angle slightly. Don't meter the glare.)

Usually you can rely on meter readings off the card. But if your subject is sidelighted (and the card is facing the light), open up a stop. If your subject is very dark, open up a stop (note this is the opposite correction from that when you meter directly); and if it's very light, close down a stop.

P9-BID-964

A FIELD GUIDE

DOG FIRST AID

Emergency Care for the Hunting,
Working, and Outdoor Dog

by Randy Acker, D.V.M.
with Jim Fergus

Wilderness Adventures Press

Published by Wilderness Adventures Press™
P.O. Box 627
Gallatin, Gateway MT 59730
Phone; 1-800-225-3339
FAX; 1-406-763-4911

10 9 8 7 6 5 4 3 2

Printed in the United States of America.

Library of Congress Catalog Card Number:
ISBN 1-885106-04-1

Table of Contents

Introduction ..5

Preventing Injury and Illness8

Eye Injuries/Problems11

Ear Injuries/Problems.15

Examining and Diagnosing Lameness17

Pad and Foot Injuries/Problems 20

Shock. .. 27

Gunshot 29

Broken Bones/Fractures/Dislocations. 32

Bleeding/Lacerations. 39

Ingestion of Poison/
Carbon Monoxide Poisoning 44

Vomiting/Diarrhea. 48

Choking, Coughing, Gagging, Sneezing 52

Allergies/Allergic Reactions. 56

Heat Stroke. 57

Burns/Scalding 59

Hypothermia/Frostbite 60

Animal Pests/Insects 61

Drowning 64

Snake Bite. 66

Fishhook Injuries 68

Dosage Chart 69

First Aid Kit/Supplies71

To the dogs of the world,
the best friends people can have.

Introduction: Using this Guide

Treating sporting and active outdoor dogs has been a major part of my Idaho veterinary practice for the past fifteen years. Because many of my clients asked me for information about how to treat their dogs in an emergency situation while in the back country, I began holding regular field dog first aid courses. Those classes were the genesis for this field guide.

Nothing can ruin a day afield, and sometimes an entire trip, faster than a dog injury or illness— or worse, the accidental death of a dog. In most cases, with some basic training, the proper first aid supplies and a little common sense, injury and illness are both preventable and treatable.

This guide is intended for use in treating emergency medical situations that arise in the field. It can be carried in a jacket or hunting vest pocket, in a canine first aid kit, backpack, or game bag. Each page is keyed for quick reference to specific dog illnesses, injuries, and related first aid topics. The spiral binding allows the user to lay the book down; it will stay open to the pertinent subject, freeing both hands to treat the patient. In each section there is 1 field treatment marked with double bullets (••), indicating the most important procedure.

Rx — Throughout the book, this symbol is used to indicate prescription drugs. *To obtain these drugs you need to make an appointment with your veterinarian, who will decide whether or not to prescribe them for your dog.* The drugs should be labeled specifically for your dog and should indicate dosage requirements and the expiration date.

Please read through this guide to familiarize yourself with the contents before taking it into the field. Though we have tried to summarize here the most common and significant canine medical problems that might be encountered in the outdoors, this book cannot, by definition, be medically comprehensive; it will be most useful to you as an adjunct to other canine health care sources and training (see: **SUPPLIES** p.71 for list of recommended publications).

We urge all owners of active outdoor dogs to take a canine first aid course, and to go over the information, medications, and procedures discussed in this guide with your own veterinarian. There is no substitute for hands-on experience and professional demonstration, and it will help make this field guide that much more "user-friendly" to you. Remember, if your dog is injured or taken ill in the field, get to the vet as soon as possible. That's what we're here for.

Randy Acker, D.V.M.

WARNING!

Your dog's health is important, but yours is, too. Any dog, no matter how normally gentle and non-aggressive, will bite when injured, frightened, or in pain. For this reason, it is highly recommended that a muzzle be included among your first aid supplies.

WARNING!

This guide is not intended to be a substitute for professional veterinary care, advice, or treatment. The author disclaims any responsibility or liability for any loss that may occur as a result of the information, procedures, or techniques presented herein.

Preventing Injury and Illness

Consider these safety factors before taking your dog into the field:

1. Is your dog in shape to handle the type of exercise it is about to do?

 A regular exercise regimen, especially in the winter and the off-season, is the best precaution against overexerting your dog and can help prevent injuries such as abraded pads and pulled muscles. Obesity and other physical problems can severely limit your dog's stamina and abilities. Talk to your vet or dog trainer about conditioning programs. Trimmed nails will prevent broken ones. Consider a field-cut for longhaired dogs to prevent foxtail and burr accumulation.

2. Is the area to which you are traveling full of snakes, hot springs, or other hazards?

 There are certain situations when it may be better to leave the dog at home. It is important to consider: cactus, toxic ponds, porcupines, skunks, foxtails, poison ivy or oak, fleas, ticks, mountain lion, badger, bear or other wildlife. Find out if heartworm, Lyme disease or other communicable diseases exist where you are going and make sure your dog is current on vaccines and worming.

When you do take your dog into areas with known hazards, make sure that you are carrying the necessary first aid supplies. (See: SUPPLIES p. 71 for list of recommended first aid supplies.)

3. Is the weather going to be excessively hot or cold?

 Summer hiking and early season hunting can be particularly dangerous—as can thin ice on ponds and rivers (dogs are NOT smart about this). Use good judgement in not pushing your dog beyond its limits.

4. How old is your dog?

 If your dog is arthritic you may want to premedicate with arthritis medicine before and after the trip. Remember that by the age of 10 years or so, your dog is a senior citizen and may not be capable of the kind of exercise it handled just last season. Loyalty and desire will make them follow you into almost any situation, but arthritis, bad hearts, and other conditions of old age may have you carrying them home.

5. Do you have plenty of water and food?

 Be sure to carry along plenty of extra water for your dog in the field. This is particularly critical on outings in dry regions where water is not naturally available. Your dog will also require more food than usual if it is working hard in the field for extended periods.

6. Do you have first aid supplies and know how to use them?

When you see that your dog is hurt, try not to panic. You do have the capacity to influence the outcome. With each injury or illness there is normally 1 major problem that needs to be dealt with and this book should help you determine what to do. Remember that common sense and certain human first aid techniques apply to dogs as well.

7. Are you transporting your dog safely?

Do not transport your dog in the back of a pickup truck without a dog box, or unless the dog is restrained so that it cannot fall out. If you must ride your dog in the back of the truck, use a simple cross–tie method (with 2 leads attached to the collar and the opposite corners of the front of the truck) to prevent the dog from jumping or falling out. I have fixed many broken legs of dogs whose owners insist that they'd never had a problem with riding in the back of a truck before. I have also seen a few dogs who had lost a considerable amount of hair and skin from being dragged along at 50 m.p.h. with their collar hooked to one corner of the truck. Although dogs often ride without incident in the back of trucks, eventually they will fall out. Not only does this accident frequently result in broken bones, it is often fatal.

Eye Injuries/Problems

Canine eye problems range from common irritation to potentially sight-threatening injuries. Examining the eyes in the dark with a flashlight can help reveal serious problems. Consult a veterinarian immediately if any of the following symptoms are present:

• Differently sized pupils
• Apparent deep cut in the cornea (See: *Corneal ulcers*, below.)
• Clear fluid leaking through the eye as in a gunshot wound.

WARNING!

Do not put any substance in dog's eyes that is not specifically intended to be used in the eyes. Eyewash, contact lens solution, etc. have the same osmolality as the canine eye and will not damage them. In an emergency, when eyes are damaged by acid, cement dust, or other caustic materials, you may use water to flush. Talk to your vet about dispensing eye ointment and eyewash for your first aid kit.

Conjunctivitis (eye infections)

A common problem, conjunctivitis is the inflammation of the tissues around the eyes, and usually involves both eyes. This is not an extreme emergency.

Symptoms
• Both eyes red and runny
• Mucus discharge at inside of eyes
• Possible pawing at the eyes

Causes
• Dust; dirt; water; thick weeds; pollen
• Bacterial or viral infection
• Allergic reaction

Field Treatment
•• Rinse eyes with eyewash to remove dust and irritants.
• If you have a diluted boric acid eyewash solution, administer twice a day.

Rx - Antibiotic eye ointment.

Corneal ulcer

A cut, scratched, or perforated cornea, this injury usually involves only one eye. Corneal ulcers are potentially serious and should be examined.

Symptoms
• Opaque or hazy spot on cornea visible when illuminated by flashlight in the dark.

- One eye partially closed.
- Constant squinting of one eye (sensitivity to light).
- Possible redness, mucous discharge, or pawing at the eye.

Causes
- Heavy brush; thorny bushes; briars
- Foreign body (foxtail seed) stuck behind 3rd eyelid.
- Many others

Field Treatment
- Check outer eye for easily accessible foreign body and remove if possible using tweezers or moistened Q-tip (do not damage the eye with the tweezers). If you remove the foreign body or foxtail, most corneal ulcers will heal with no treatment in 2-3 days.
- Prevent dog from pawing at eye and, if necessary, put an "Elizabethan" collar (E-collar), or bucket on dog to prevent scratching and rubbing of eye. (See: **SUPPLIES p. 13**).
- Apply field treatment for *Conjunctivitis* and **SEE VETERINARIAN**.

Rx – Topical anesthetic drops (Fluoracaine) deadens the eye tissues, stops pain, decreases pawing, allows you to look for foreign bodies, and stains corneal ulcers green.

Rx – Antibiotic eye ointment.

WARNING!

In treating corneal ulcers, antibiotic eye ointment must not contain a steroid. Also, do not allow Betadine solution in the dog's eye. These can further damage the cornea.

Swollen eyelids
Symptoms
• Swelling around the eyelids, mouth, and head.
• Pawing at the face.
NOTE: Stings from bees, hornets, or other insects can cause eyes to swell shut within 1-2 hours.
Field Treatment
• If you can find the stinger, remove it.
NOTE: Canine airways will not usually swell shut as a result of insect bites, and time will generally relieve above symptoms without treatment.
• Administer over-the-counter antihistamines. Baking soda or calamine lotion may help. (See: **DOSAGE CHART**, p. 69.)
CAUTION: Over-dosing may cause sleepiness.
Rx - Prednisone may be indicated if swelling is severe.

Abraded eyelids
Hunting dogs will frequently abrade their eyelids when hunting hard through briars or deep cover. This is not generally a serious problem.
Field Treatment
• Apply antibiotic ointment to eyelids.

Ear Injuries/Problems

Emergency or "acute onset" injuries to the canine ear usually involve penetration by foxtail seed or a cut ear margin. Ear infections are also quite common, especially in certain breeds, and do not generally constitute an emergency.

Foxtail seed in ear
Symptoms
• Rapid onset of head shaking— usually occurs in the field or immediately after outdoor activity in summer or fall when grasses are dry.
• Scratching at ear
• Head- tilting
Field Treatment
•• Try to remove grass seed with fingers or tweezers before it gets deep in ear canal.

NOTE: Due to the curvature of the dog's ear canal, it is difficult to damage the ear drum
• Otoscope & alligator forceps are usually required to remove grass seed from ear canal. **SEE VET.**

NOTE: This is not an extreme emergency but one that needs to be treated. Grass seeds can penetrate the ear drum, but this is not common.

Rx - Topical anesthetic drops (see: *Corneal ulcer,* p. 12) can be used to calm a dog in severe pain due to foxtail in ear.

Lacerated ear margin

Symptoms
- Profuse bleeding from the margin of the ear
- Bleeding will not stop because of centrifugal force (caused by shaking the head) and ear flapping against head.

Field Treatment
- Try to stop bleeding by applying Blood Stop powder, corn starch, styptic pencil, Quick Stop, cold water, or ice and pressure.
- •• Wrap thoroughly by covering ear and head with sock or nylon stocking— with hole cut out for good ear— and taping to head. (See illustration).

NOTE: Avoid frequent washing as this removes scab and encourages additional bleeding. You may want to have this sutured in order to prevent resumed bleeding or for cosmetic reasons.

Aural hematoma— a broken blood vessel resulting in a large, swollen ear. A thick, fluid–filled blister can occur if the dog shakes its head too much. This will need to be drained.

Hint: A tubular structure such as a nylon stocking, men's sock (end cut off), or cast stockinette works well to start this bandage. Use tape in front and in back to start. Uninjured ear is out of hole.

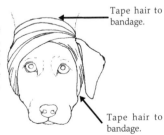

Tape hair to bandage.

Tape hair to bandage.

Examining and Diagnosing Lameness

It is not unusual for dogs to pull up lame in the field. A simple exam can help reveal the cause and determine whether or not the problem is serious. Follow the procedures below to make your diagnosis. Please refer to the appropriate tabs for further treatment information:

1. Beginning with the toes, examine each nail carefully— small cracks can become infected and cause lameness. (See: **FEET**, p.20.)

2. Push gently on each pad looking for signs of swelling or sensitivity. Examine each pad and between the toes looking for cuts, abscesses, blisters, or foreign bodies such as cactus spines, thorns, glass or metal shards. (See: **FEET,** p.20)

3. Flex and extend each toe—if this elicits a painful reaction, or if you hear a slight clicking sound, it could indicate a fracture. (See: **BONES,** p. 32.)

4. Feel all the bones up the leg—heat, painful reaction, or swelling can indicate a fracture (See: **BONES**, p 32.)

5. Compare the lame leg to the opposite leg— this can help you to differentiate normal from abnormal.

6. Flex and extend the wrist, elbow, shoulder (front leg), or ankle, knee, and hip (hind leg)—

pain in the joint can indicate arthritis, infection or bone chips.

7. Feel the entire leg for punctures, swelling, or evidence of skin breaks that indicate punctures. Examine all abnormal skin spots. Even a small puncture can abscess.

Bone and joint problems in older dogs

- Older dogs often have **arthritis**, which can cause chips to form in the joint. These chips can get between the joint surfaces causing the joint, which was previously sore to suddenly become quite lame.
- Many older dogs of the large breeds have **back problem**s. This can cause reluctance to jump in the car, soreness after exercise, and pain when pressed above tail and low back area.
- **Hip dysplasia** is indicated by a painful reaction when the hips are extended.

Field Treatment

•• Enteric-coated aspirin or Bufferin. (See: **DOSAGE CHART**, p. 69.)

NOTE: When using these products, if you observe vomit with material that looks like coffee grounds, or if you observe black stools, stomach ulcers may be indicated and the treatment should be stopped. Never give aspirin to cats.

Bone and joint problems in younger dogs

- Younger dogs often have growth related problems due to **joint abnormalities**. If the lameness is persistent or chronic (lasting for 3 to 4 weeks, or recurring regularly), this usually indicates a joint problem. X-rays are generally required to determine if this can be corrected.

Pad and Foot Injuries/Problems

Pad and foot injuries are quite common and can quickly ruin a trip. It is important to learn basic foot bandaging procedures.

Cut pads
Symptoms
• Deep cut visible in pad
• Profuse bleeding
Causes
• Sharp rock; ice; metal; glass
Field Treatment
• Remove any foreign bodies (dirt, rock, glass, etc.).
• Rinse with antiseptic cleanser (Betadine, Nolvasan).
• Apply antibiotic ointment.
•• Bandage (see below).

NOTE: Although pad cuts may bleed profusely, they are generally not extreme emergencies, and suturing is often optional. With proper bandaging and care, most pad cuts heal within 2 weeks.

Foot bandage (see illustration.)
• Apply non-sticky dressing (Telfa pad) and wrap loosely with gauze.
• Wrap over gauze with elastic tape.
• Wrap over elastic tape with waterproof tape.

• Keep bandage clean and dry until healed.

NOTE: Entire foot must be wrapped in order to keep bandage in place. In case of heavy bleeding, wrap pad with tight bandage for 2 hours, then re-wrap with looser bandage. Consider using dog boots over the bandage.

a. Cover wound with telfa pad and gauze.
b. Wrap with gauze several times.
c. Wrap with elastic tape.
d. Wrap snug with white tape to hold it on.

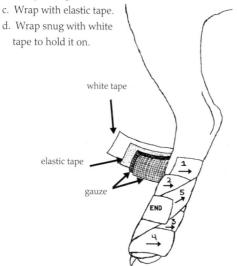

white tape

elastic tape

gauze

Foot Bandage wrap sequence

Dog boots

Dog boots are useful in areas with sharp rocks, cactus, ground thorns, or sand burrs. You should probably have boots to put over foot bandages since it is difficult to keep such bandages on for the duration. If your dog practices with the boots at home it will be accustomed to wearing them if injured or if you plan to venture into rough terrain or cactus country. (See: **SUPPLIES** p. 71.)

Removing tar/oil from feet

• Shave feet.
• Use baby oil or mechanics' hand cleaner to remove tar .
• Clean with soap and water.

WARNING!

DO NOT use gasoline, turpentine, or any other toxic substance to clean feet.

Torn nail

Though not an extreme emergency, torn and severely split nails should be removed promptly following the procedures listed below. Most nail injuries heal quickly and the nail will almost always regrow when extracted. Bone infection can result from torn nails, requiring toe amputation.

Symptoms
- Frequent licking of toe
- Nail visibly split

Field Treatment
- Muzzle dog (See: **INTRODUCTION** for warning).
- Trim other unsplit nails.
- Grasp torn nail firmly with hemostat or needle-nose pliers and pull off forcefully.

NOTE: If unable to do this, trim split nail as short as possible.

- Clean toe with Betadine solution.
- Bandage.

Rx - A broad spectrum antibiotic.

Prevention
- Keep nails regularly trimmed.

CAUTION: If nails are trimmed too short, they will bleed, sometimes for hours. Taking small bits off can help you avoid cutting into the quick and Quick Stop powder or styptic pencil can stop the bleeding. (See illustration.)

Correct angle of cut/trim

Skin

Nail

Bone

Line of nail splint

Pad & Foot Injuries

Abraded or blistered pad

This injury usually occurs after running on shale slopes, pavement or other hard surfaces early in the season.

Symptoms

- Tiptoe stance on all 4 feet within one day after a long hike.
- Limping or obvious discomfort while walking
- Blisters; open sores; raw, abraded spots on pad.

Field Treatment

- Keep pad clean.
- Apply pad toughener. (See: **SUPPLIES**, p. 71.)
- Bandage (optional).

NOTE: Pad abrasions and blisters generally heal with or without treatment. The best treatment is 1 to 2 weeks of rest.

Prevention

- Preconditioning— acclimate dog's feet gradually to the type of terrain.
- Apply pad toughener 1 month prior to hunting or other strenuous outdoor activity.

Foxtail seed between toe

Foxtail seed injuries are most typical in long-haired dogs and usually occur in late summer and early fall (August to October) when grass seeds are dry.

Symptoms

- Red, inflamed spot between toes, often draining puss.
- Frequent licking between toes.

Field Treatment

•• Break through abcess and remove foxtail with hemostat.

CAUTION: Seeds may be difficult to locate, and dog may require muzzling during probing. After foreign material is removed, wound should heal in 3 days with no further treatment. If it continues to drain there is still a foreign body in the wound.

Prevention

- Field clip prior to foxtail season, especially between the toes, removing all matted hair.

Cactus injuries

Cactus poses a common threat to dogs' feet in the Southwest, and other arid regions. Some hunters and hikers use dog boots on their dogs in heavy cactus areas (see: **Dog Boots**). Others do not, as thorns will often pass through the boot material and into the foot, causing hidden aggravation and more serious injury.

Field Treatment

Rx– Broad spectrum antibiotics.

•• Examine and remove all thorns if possible.

- If thorns have broken off in the pad, you will

detect pain, redness and increasing lameness over a few days. These injuries can potentially cause tetanus and should be treated by your veterinarian as soon as possible. Soaking in Epsom salts may help.

Fractured toe

Symptoms
• Swelling; pain; clicking feel; immediate lameness

Field Treatment
• Bandage Foot. (See: **FEET**, p. 20.)

Shock

A condition in which the cardiovascular system cannot adequately perfuse tissue, shock is relatively rare in dogs, but does represent a serious emergency. Any dog injured severely enough to go into shock should be taken to a vet as soon as possible.

Symptoms

• Rapid heart rate (normal rate is 70- 140 beats per minute; above 160 beats per minute indicates shock.)

TO TAKE THE HEART RATE: Feel the chest behind the left elbow; count the beats in 10 seconds and multiply by six. (Practice it now just to feel comfortable with the procedure.)

• Pale or blue gums; general weakness; cool membranes; collapse.

Causes

• Bleeding; trauma; fear; severe infection.

Field Treatment

1. GATHER INFORMATION

• Is the dog breathing? Are there occluded airways?
• What is the dog's heart rate?
• Are there broken bones? Where?
• Is there bleeding? Where and how much?

2. CORRECT THE WORST PROBLEM FIRST

• If there is no heartbeat, administer CPR. (See: CPR in **DROWNING**, p. 64.)

- If there is no breathing, clear the airway, hold the mouth closed and breathe for the dog, your mouth into its nose.
- If there is severe bleeding, stop it. (See: **BLEED-ING,** p. 39.)
- If bones are broken, splint if appropriate. (See: **BONES**, p. 32.)
- If your dog is vicious and resisting treatment it may be best to make it comfortable, cover it with a blanket and head for the vet. Do not disturb further as you could aggravate the shock.

3. CALM THE DOG

- Elevate the body above the head if dog is unconscious.
- Keep dog warm.
- Deliver oral fluids if conscious (can use syringe into mouth.)
- Use caution with chest wraps, muzzles or anything that might cause difficulty with breathing.

NOTE: Shock is nature's way of supplying vital organs with blood and oxygen. Be sensitive to the dog's needs as it will naturally try to heal itself. Allow the dog to stand up if it needs to do so to breathe easier. Do not bandage or muzzle if that inhibits breathing. Arrange the dog in a comfortable safe position, correct any major problems and then leave it alone.

Rx - Prednisone is sometimes indicated for treatment of shock, severe pain or arthritis.

Gunshot

In treating any gunshot injury, it is necessary to first determine the severity of the wound. For example, the accidental peppering of a hunting dog by shotgun pellets at long range will barely penetrate the skin. A BB gun will penetrate the skin but will rarely penetrate the abdomen or chest, except at very close range. A pellet gun can, and often does, penetrate the abdomen and can cause death from peritonitis (see symptoms below.) Any caliber of rifle will also penetrate and rupture organs. If you believe that the gunshot has penetrated the abdomen or chest and ruptured organs or lungs, this is an **EMERGENCY** and you must get the dog to a vet as soon as possible.

Symptoms of bullet or pellet wound
• A single round hole in skin with bruising around it
• Hair in the wound or sticking out of it (possibly)
• Dog acting dull, listless, uncomfortable
NOTE: Dogfight wounds, by contrast, display 2 holes from the canine teeth and multiple punctures.

Penetration of skin by lead or steel shot

X-rays of most hunting dogs reveal the presence of lead shot under the skin, usually as the result of rogue pellets or careless shooting. Unless they involve eye injuries, instances of long-range peppering by shotgun are usually not emergencies.

Field Treatment

•• Pull hair from wounds with tweezers or hemostat.
• Remove pellet if possible.
• Clean wounds with antiseptic cleanser— (Nolvasan, Betadine).
• Dress with antibiotic ointment, pushing the ointment into the holes if possible.
• Watch for symptoms of peritonitis.

NOTE: Lead shot can usually be left in body and will eventually be walled off by scar tissue. Steel shot may need to be removed as it can cause draining tracts due to rusting.

Rx - Broad spectrum antibiotic.

Symptoms of peritonitis— Emergency: SEE VET

• Abdominal pain
• Tucked up abdomen
• Possible fever developing over a period of several hours (103° or above)
• Vomiting
• Possible diarrhea

Sucking chest wound

Causes

- Penetration of chest by shot, pellet, bullet, wood, or arrow
- Dogfight wound

Symptoms

- Hole in side of chest
- Skin moves up and down or air visibly fills under the skin.
- Sucking sound into chest cavity
- Dog is breathing rapidly or getting shocky (See: **SHOCK.**, p. 27.)

Field Treatment

- Push down on side of chest to force air out.
- Blow in dog's nose, keeping its mouth closed, to help expand the lungs
- •• Apply occlusive dressing bandage: bandage thickly coated with vaseline or first aid cream (antibiotic ointment) to form air–tight seal.
- Wrap with tape or use your hand to hold the bandage in place while transporting dog to vet.

NOTE: The goal here is to remove the air from between the lungs and rib cage, so that when the ribs expand the lungs will reinflate; and then to close the hole so outside air will not re-enter the chest cavity.

CAUTION: Avoid wrapping chest too tightly as this can constrict breathing.

• **EMERGENCY: SEE VET.**

Gunshot

Broken Bones/Fractures/Dislocations

Broken bones are not common unless a dog is hit by a vehicle or falls out of a moving truck (see: **PREVENTION,** p. 8 for safe transportation techniques). The primary goals in treating broken bones and fractures are to reduce pain, prevent infection and prevent the bone ends from further damaging the animal.

Field Treatment

Many broken bones resulting from car accidents are associated with other serious injuries that also require treatment. If you see a dog that has been hit by a car, use common sense and first pull completely off the road to avoid a traffic accident. Follow these general procedures:

- Muzzle. (See: **INTRODUCTION** for warning.) These dogs are in pain and afraid and will often bite.
- Treat bleeding or shock as required.
- Administer drugs for pain relief or infection as required (see: **DOSAGE CHART,** p.69).
- Check airway and breathing.
- Carefully feel the bones.

RX- Broad-spectrum antibiotics.

NOTE: Slight stress to the limb will often reveal a "click," which indicates one bone rubbing against another.

WARNING!

Use caution when feeling bones to prevent further damage to the fracture.

• After determining which bones are affected, follow procedures under appropriate headings below:

Broken back
Symptoms

• Anus gaping open and will not pucker when pinched.
• Hind legs and tail not moving.
• Manual examination may reveal major discrepancy in alignment of vertebrae.
• Front legs may be straight out and rigid.

WARNING!

If misalignment of vertebrae is detected, prognosis is very poor. If dog is able to move legs, tail and anus, the prognosis is somewhat improved.

NOTE: Inability to move hind legs can also indicate spinal shock, which may be reversible.

Field Treatment

• Muzzle dog. (See: **INTRODUCTION** for warning.)

•• Immobilize by **CAREFULLY** moving dog onto a board and duct taping or tying it down. Avoid causing further damage to the spinal cord while moving the patient.

• **GET TO VET**.

NOTE: In some cases when a dog suffers a severely broken back in the field as a result of being hit by an automobile, the prognosis is clearly hopeless. In such a situation when there is no way of transporting the animal to a vet without causing further, needless suffering, the most humane act may be to put the dog down. Only the dog owner can make this extremely difficult decision.

Broken pelvis

Symptoms

• Reluctance to walk on one or both hind legs

Field Treatment

• Keep dog quiet.
• Observe urine for blood or abnormally small volume, which can indicate a ruptured bladder.

Broken ribs

Most broken ribs heal without treatment, but you do want to have your dog examined to detect more serious injuries such as internal bleeding and lacerated lungs.

Symptoms
• Clicking sound when feeling over ribs.
• Pain or swelling over rib cage.

Field Treatment
• Keep the dog quiet; a broken rib can go inside and lacerate a lung.

NOTE: If a section of the ribs moves opposite to the phase of respiration, this indicates a flail chest that is a more serious injury, requiring immediate veterinary attention.

Broken humerus/femur
These injuries often swell quite a bit and can precipitate shock. (See: **SHOCK**, p. 27.)

Field Treatment
• Control bleeding as required.
• Keep dog quiet to prevent bones from damaging arteries, veins, muscles or nerves.
• Aspirin or Bufferin help with pain if you have a long trip home (See: **DOSAGE CHART**, p. 69.)

Dislocations
This occurs when ligaments tear around the joint.

Symptoms
• Knee and foot point out (dislocated hip).
• Limbs oddly angulated (dislocated elbow).

Broken Bones

Field Treatment
- Aspirin or Bufferin (See: **DOSAGE CHART,** p. 69.)

NOTE: Although dislocated joints do not generally present a dire emergency, they require veterinary treatment as dogs must be anesthetized before joints can be put back into place.

SPLINTABLE BONES (lower leg bones.)
Broken radius ulna
Broken tibia or fibula
Broken foot or paw

Splintable Bones

Field Treatment
- Control bleeding as required. (See: **BLEEDING,** p. 39.)
- If bone protrudes from skin, clean with antiseptic cleanser (Betadine, Nolvasan) or 3% hydrogen peroxide and push bone back under skin, if possible.

NOTE: Save any bone fragments that might be loose on the ground for possible surgical reconstruction and wrap them in a clean, moist cloth.

- Apply Telfa pad covered with antibiotic ointment.
- Wrap with gauze.
- • Apply "Robert Jones" bandage to prevent laceration of artery, vein, or nerve by sharp bone points, and to decrease swelling (see illustration and definition below).
- Aspirin or Bufferin (See: **DOSAGE CHART,** p. 69).
- Treat for shock if necessary (See: **SHOCK.,** p. 27)

Robert Jones Bandage
- Clean wound and apply antibiotic ointment, Telfa pad, gauze.
- Apply **THICK** layer of padding (cotton is best, or towel, etc..).
- Wrap firmly with elastic tape or Ace bandage.
- Apply stick or rolled newspaper for support.

Broken Bones

Apply these support wraps so they cover a joint above the fracture and a joint below the fracture.

- If the bandages are going to be on a long time, make sure you check for circulation problems: toes cold, blue or swollen.

thick layer of cotton

2nd gauze

Finished leg

e l a s t i c bandage

tape

1st gauze

Note
– A thick layer of cotton over the leg applies even pressure and helps prevent problems with blood supply.
– Tape stick, ruler, etc. over bandage to add stability.

Robert Jones Bandage Cross-section view

elastic bandage

2nd gauze

gauze; snug

thick layer of cotton

LEG

stick, ruler, metal

tape

Broken toes
Field Treatment

- Apply foot bandage. (See: **FEET**, *Cut pads.*, p. 20.)

Bleeding/Lacerations

Arterial bleeding is usually more forceful, brighter red, and pulsating. It will be going away from the heart. **Venous** bleeding will be more constant, bluish and going toward the heart.

Field Treatment

1. CONTROL BLEEDING

Use the least traumatic method you can to control bleeding. Depending on the severity of the wound, you may need to be more aggressive.

a. Apply direct pressure with clean cloth or gauze sponges and bandage.

b. Apply pressure with your hand above the wound for **arterial** bleeding. For **venous** bleeding, apply pressure below the wound. If bleeding stops after 5 minutes, bandage.

c. Hemostats can be used to grab large, pulsating arteries or veins. Be careful not to clamp nerves or a lot of extra tissue. If you have a long way to go, hold the bleeding artery out with a hemostat and tie a square knot over it with the most appropriate material available.

d. If a limb is cut off, non-salvageable, or if other methods don't work, apply tourniquet (see below.)

NOTE: It is okay to look into wounds, blot them dry and attempt to find bleeders if the situation requires that. Don't panic and carry your dog for

an hour or two while they bleed all the way back to the car. Remain calm and do what you can to stop the bleeding before transporting your dog anywhere.

Keep in mind that a Labrador can bleed at least a pint of blood before real problems occur. This, of course, varies with the size of the dog.

2. CLEAN THE WOUND

• Clean with antiseptic cleanser (Nolvasan, Betadine.)

Rx - Broad spectrum antibiotic. (See: *Torn nail*, in FEET, p. 22.)

3. BANDAGE

a. Dress wound with antibiotic ointment.

b. Cover with Telfa pad.

c. Wrap with gauze.

d. Tape.

e. Treat for shock as required (see: **SHOCK**, p. 27).

WARNING!

Because they impede circulatory function, tourniquets if applied too tightly for too long a period of time can result in loss of the limb. For this reason, tourniquets should only be used when all other methods of controlling bleeding have failed.

Tourniquets

1. Wrap a sash, or folded strip of cloth (about 1" wide) twice around the bleeding extremity, 1 inch or so above the wound.
2. Cross the ends of the material and tie them around a stick or other hard object (a pen, a closed pocket knife, etc.)
3. Twist the stick like a faucet, tightening the material until the bleeding stops.

CAUTION: Avoid excessive pressure.

4. Wrap the stick with bandage material, tape, or another piece of cloth to hold in place.

<u>WARNING!</u>

Loosen tourniquet every 15 minutes for a period of 1 to 2 minutes in order to allow circulation to the limb. **SEE VET.**

Bleeding tail
Causes
- Hunting in areas of heavy, briar–infested cover.
- Barbed- wire fences
- Chronic wagging against a chain–linked fence.

Field Treatment
- Clean wound with antiseptic cleanser.
- Apply antibiotic ointment.
- Do not clip hair, as hair can help in blood clotting.
- • Apply bandage.

Bleeding

Tip: Tape a tubular structure over the tip of the tail. (A syringe case with the end cut out works well for this.) Pull hair up around tube and tape over to help hold bandage in place (see illustration).

CAUTION: Avoid bandaging too tightly as this can cut off the blood supply completely.

Important: tape hair to tubing. Do not tape tail tightly or constrict blood flow to tip of tail.

Tubing extends out over split tail

Torn dewclaw

Torn dewclaws will often bleed profusely but do not generally constitute an emergency.

Field Treatment

- Clean with antiseptic cleanser (Nolvasan, Betadine).
- Apply antibiotic ointment.
- Apply gauze.
- Tape dewclaw to the leg.

Pad lacerations
(See: **FEET/PADS,** p. 20.)

Barbed wire lacerations

These occur on the front of the legs, chest, and penis and often will go unnoticed by the dog and owner. It is important to check your dog throughout the day as the wound can become infected from weeds, grass, and dirt.

Field Treatment
• Clean wound with antiseptic cleanser (Nolvasan, Betadine).
• Bandage, if necessary.

Sucking chest wounds/Penetrating abdominal wounds
(See: **GUNSHOT**, p. 29.)

Bleeding

Ingestion of Poison
Carbon Monoxide Poisoning

Ingestion poisoning

If you think your dog has eaten a poisonous or possibly toxic substance, the primary goal is to get the substance out before it is absorbed into the system. As most dogs will not eat caustic substances— i.e. those that will burn skin, mouth, or esophagus— in general, the recommended treatment is to induce vomiting. See **WARNING!** below.

Field Treatment

•• Induce vomiting with salt, hydrogen peroxide, or syrup of ipecac. (See: **DOSAGE CHART**, p. 69.)

Rx– Apomorphine

WARNING!

DO NOT induce vomiting if:

• Dog is unconscious.
• Substance is a caustic, or a corrosive, i.e., will burn the esophagus (battery acid, detergent, lye, oven cleaner, paint, floor wax, etc.).
• Object is very sharp and could tear the esophagus or stomach.
• It has been 3 or more hours since the poison was ingested.

ONCE THE POISON IS VOMITED UP, CONSIDER THE FOLLOWING STEPS:

1. Contact the **NATIONAL POISON CONTROL HOTLINE:** 1-900-680-0000 or 1-800-548-2423.
2. **SEE VETERINARIAN**, if possible.
3. If you feel poison is still in the system, delay absorption by feeding activated charcoal or Toxiban liquid, which can bind toxins and prevent their absorption. Milk, egg whites, or vegetable oil can also be used.
4. Save the container or vomit as many poisons have specific antidotes.
5. Make careful note of the amount of poison you think was absorbed into the dog.
6. Wash poison off the feet or coat, if that is appropriate. Don't get toxic substances on yourself.

Note: If vomiting immediately follows the poison ingestion and a large amount of dog food was consumed before the poisoning, you may decide that all the poison has come out. Use your judgement.

Old barns, cabins, and mines have many toxic substances and some dogs will eat anything. If you think there is even a remote possibility that your dog consumed a toxic substance, it is better

to induce vomiting now than be sorry later. The symptoms are also variable, depending upon the substance, amount eaten, and time since consumption. Sometimes **smelling the breath**, **examining the mouth**, or **investigating where the dog has been** can give you a clue. Red and green grains or other colors in the vomit can indicate poison.

Some toxic substances and their indications

- Rat and mouse poison (including D- Con): bleeding (not immediate)
- Antifreeze: drunken behavior (0- 4 hours); kidney failure (within days)
- Strychnine, 1080: seizures
- Chocolate: signs of toxicity (vomiting, diarrhea, increased heart rate, rapid breathing, muscle tremors, seizures, coma)

WARNING!

Chocolate contains a caffeine–like alkaloid that can be quite harmful or fatal to dogs.

- Large quantities of aspirin, Advil, other human pills; garbage; rotten meat; many plants (save them for identification).

Carbon monoxide poisoning
Causes
• Exposure to exhaust fumes during transport in vehicle.
Symptoms
• Deep red gums
• Heavy panting
• Increased temperature
• Depression
• Muscle twitching
• Acting drunk
Field Treatment
•• **EMERGENCY—provide fresh air immediately**
• If unconscious, perform mouth to nose respiration: Hold dog's mouth closed, blow deeply into nose until chest expands. Repeat until dog starts breathing on its own.

Vomiting/Diarrhea

Vomiting

Occasional vomiting— often as a result of eating grass— is common in dogs and usually not dangerous. It is valuable to know the contents of the vomit as some substances are toxic or will perforate or block bowels. Examining the pile will often reveal the cause; pieces of tinfoil, bones, etc. suggest "garbage intoxication." Consult vet if vomiting is chronic or poisoning is suspected. (See: **POISON**, p. 44.)

Causes
• Diet
• Excitement
• Food poisoning
• Eating grass
• Many others

Danger Signals
• High fever (103 degrees and above)
• Abdominal pain or bloat (**EMERGENCY! See:** *Stomach torsion*, below.)
• Blood in vomit
• "Coffee grounds" in vomit (indicates stomach bleeding).
• Dehydration

Symptoms of dehydration
• Gums sticky
• When skin between shoulder blades is lifted, it will stay in a ridge.

Field Treatment

• Stop hunting or hiking if vomiting is continual (5 times or more).
• Withhold all food for 24 hours.
• Give small amounts of water every hour or two.
• Administer Pepto-Bismol every 6 hours (see: **DOSAGE CHART,** p. 69).
• Feed cooked rice or bland diet after 24 hours.
• Watch for signs of peritonitis.

NOTE: When dogs drink large quantities of water and then vomit, they deplete themselves of electrolytes, which can cause other complications. Consult your vet.

Diarrhea

Occasional diarrhea in dogs can be a normal response to excitement, dietary change, travel, or change of environment. **SEE VET** if diarrhea is chronic or if dog displays any of the following symptoms.

Danger Signals

• Blood in stool
• Black, tarry stool indicates upper G.I. bleeding.
• Dehydration (See symptoms above.)
• Abdominal pain (determined by pushing on abdomen).
• High fever

Vomiting/Diarrhea

Field Treatment— for non-emergency vomiting and diarrhea.

• Administer Kaopectate or Immodium-AD. (See: **DOSAGE CHART**, p. 50.)

• Feed cooked rice when food is restored.

Rx - Flagyl is a good broad spectrum antibiotic for diarrhea.

Gastric dilation

Causes

• Overeating dog food or fermentable foods.

Symptoms

• Salivation; firm distension of stomach but without a hollow sound when tapped; belching.

Field Treatment

• Induce vomiting; if unable to vomit, see: *Stomach torsion.*

Stomach Torsion

Torsion occurs when the stomach twists, closing off the in– and out–flow, so that the dog is unable either to pass gas or to belch. The resulting build-up of gas in the stomach causes bloating, and if not treated promptly, death. Although the causes of torsion are incompletely understood, it is thought that certain types of food or possibly feeding before heavy exercise may be contributing

factors. Torsion is most common in large, deep-chested breeds and is a serious emergency. **SEE VET.**

Symptoms

• Extreme bloating
• Trying to vomit but unable to do so .

Note: If able to vomit, see: *Gastric dilation*, above.

• Restlessness, pacing
• Hollow drumlike sound when abdomen is tapped.

Field Treatment

• **EMERGENCY: SEE VET immediately!**
• If dog appears to be dying and there is no possibility of getting to the vet, pierce the stomach with a large-bore needle or trocar to let the gas out. Try to hit the area just behind the ribs and relatively high as the dog is standing up.

WARNING!

Do not attempt the above procedure unless you feel that you have no other options.

Prevention

• Feed smaller meals twice daily.
• Do not exercise your dog soon after meals.

Vomiting/Diarrhea

Choking, Coughing, Gagging, Sneezing

Choking as a result of food lodged in the throat is very rare in dogs as the canine throat is well designed to accommodate large pieces of meat. However, bones, pieces of wood, grass, and cockleburs can become stuck in a dog's throat and mouth. A number of other injuries and illnesses can also cause choking-like symptoms, coughing, gagging, and sneezing. If any of these activities become chronic, consult your vet as they may be symptomatic of other more serious illnesses.

Grass pharyngitis

Symptoms
- Frenzied eating of various substances.
- Pawing at mouth.
- Gagging, drooling possible.

Causes
- Ingestion of grass or cockleburs that become lodged in throat.

Prevention
- Prevent dog from eating grass.
- After hunting or other outdoor activities, "de-burr" your dog promptly rather than letting the dog pull out burrs with teeth.

Field Treatment

•• Prevent dog from eating more foreign material.
- Examine back of mouth and larynx and remove foreign object if possible.
- Feed bread to dislodge foreign object.
- Administer cough suppressant (Chloraseptic spray—available in pharmacy) to deaden throat.

Foxtail seed lodged in nostril

Foxtail seeds are often inhaled up the nose, and due to their barb-like shape are not easily expelled. Inhalation of foxtail seeds causes violent, prolonged sneezing attacks. The injury is most common in late summer/early fall months when grass seeds are dry.

Symptoms
- Rapid onset of violent sneezing in the field
- Sneezing will persist for several days if seed is not expelled.
- A bloody discharge sometimes occurs in one nostril and after time this discharge may become pussy and infected.

Field Treatment
•• If you see a small grass seed tail coming out of the nose, pull it out.
- **SEE VET**. Foxtail seed must be removed with otoscope under general anesthesia.

WARNING!

WARNING!

This condition should be dealt with as soon as possible as foxtail seed can travel to the brain and cause an abscess.

Laryngeal paralysis

This is common in older large breed dogs.

Symptoms

- Noisy breathing increasing in severity as you hike.
- Possible history of gagging or choking.
- Possibly frantic about trying to suck air in.
- Possible blue gums and collapse.

Field Treatment

- •• Stop hiking; seek shade, calm the dog down, administer water.
- After breathing has improved, **slowly** walk back to car.

Bone caught around lower jaw

Round marrow bones, sometimes become caught around the lower jaw during chewing. You will know it when this happens to your dog.

Field Treatment

- Pull skin beneath dog's jaw back toward its body; with the other hand grasp bone and pull it slightly. The marrow bone should slip off easily. The skin bunching up at the tip of the chin

is what prevents you or the dog from pulling it off.

Bone or piece of wood lodged between back teeth

Bones or pieces of wood commonly become lodged between dogs' upper back teeth.

Symptoms
• Yawning; salivating; pawing at mouth

Field Treatment
• Examine upper mouth and remove foreign object.

Allergies/Allergic Reactions

Allergic reactions to various plants, insect bites, and other substances are common in field dogs and generally do not represent an emergency.

Causes

- Insect bites (bees, wasps, etc.)
- Exposure to toxic plants (nettles, poison ivy, etc.)
- Allergies to dust, dirt, etc. (See: **EYES**, p. 11.)
- Food allergies (See: **VOMITING/DIARRHEA.**, p. 48.)

Symptoms

- Itchy skin
- Hot spots on skin
- Red circles on stomach (reaction to nettles)
- Skin rashes (reaction to poison oak, etc.)
- Red, runny eyes; runny nose; sneezing
- Reverse sneezing (breathing in nose and out mouth)
- Swelling of head, lips, eyes

Field Treatment

- Administer eyewash and eye ointment if required.
- Wash affected skin with water.
- Apply Calamine lotion to skin.
- Apply topical antibiotic/steroid ointment.
- Administer antihistamines to reduce swelling (not always effective).

Rx - Prednisone may be indicated for severe allergic reactions..

Heat Stroke

A common and extremely serious problem among sporting, working and any dogs who travel in vehicles, heat prostration is almost always preventable with good judgement.

Causes

- Hot weather
- Heavy exercise
- Insufficient water
- High humidity
- Dog left in hot vehicles or dog boxes
- Poor conditioning

Prevention

- Mount a thermometer inside car or pickup shell for easy reference.

WARNING!

Remember, even with windows down, temperatures inside vehicles can be up to 30 degrees hotter than outside air. **DO NOT** leave dogs inside parked vehicles, even for short periods of time, especially in bright sun or hot weather.

- Make sure dogs always have plenty of water.
- When hunting, working, or exercising in hot weather, rest or rotate dogs regularly.
- Provide shade.

Symptoms

- Rapid, noisy breathing; salivation; vomiting possible
- Dog down, unable to get up; may be comatose
- High body temperature (104° to 107°)
- Staggering

Field Treatment

- •• **EMERGENCY! Cool dog down immediately.**
- Submerge in stream or lake for at least 10 minutes.
- Submerge in ice bath.
- Place in front of fan or air conditioner.

Burns/Scalding

WARNING

KEEP YOUR DOG AWAY FROM HOT SPRINGS! Accidental immersion in hot springs can cause severe scalding to dogs, often resulting in hair falling out after several days, skin sloughing off and, not unusually, death. Because dog hair holds the hot water against the skin, it is important to immerse the dog immediately in cold water or snow.

Field Treatment
- •• Immerse in cold water or snow immediately.
- • Keep as clean as possible.
- • Apply topical antibiotic ointment where blisters are broken.

Rx - Broad spectrum antibiotics

Focal Burns—Burns to the pad from hot tar, etc.
Field Treatment
- • Cool wound, if recent.
- • Clean.
- • Bandage (See: **PADS/FEET**, p. 20.)
- • Apply antibiotic ointment to prevent infection.
- • Chemical burns should be flushed with water.

Burns

Hypothermia/Frostbite

Hypothermia

A relatively rare condition in dogs, hypothermia can occasionally occur as a result of prolonged exposure to cold, or prolonged immersion in cold water.

Symptoms
- Sluggishness, altered behavior
- General weakness
- Low body temperature (95° or less)

Field Treatment
- Wrap dog in blanket.
- •• Warm with hot water bottles or car heater or your own body.

Frostbite

Frostbite most commonly occurs on the tip of the nose, ears and tail.

Field Treatment
- Rewarm affected area rapidly with moist heat applications.

Tip: Apply coffee from thermos topically, then pat dry.

<u>WARNING!</u>
Do not rub or break frozen ear tips.

Animal Pests/Insects

Skunks

Skunks pose a common, though generally not serious, threat to active outdoor dogs. Eye irritation will often result from a direct hit.

Field Treatment

- Bathe dog in tomato juice, other vitamin C product, or 1 part ammonia to 10 parts water.
- Apply Skunk Off or other skunk scent-removal product.
- Apply eyewash and eye ointment as required.

Porcupines

Porcupine quills do not usually constitute an emergency unless there are many of them inside the dog's mouth or eyes. Quills can also break off under the skin where they cause infection.

Field Treatment

- If dog has only a few quills penetrating the skin, these can generally be removed by holding down surrounding skin and grasping the quill near the skin with hemostat or needle–nose pliers and pulling firmly. Try not to break the quills off as they are difficult to locate under the skin.

Note: When you pull the quill the surrounding skin will come toward you; thus it is necessary to hold the skin close to the body to prevent nearby

quills from slipping under the skin.

- If the dog has a great many quills, especially in mouth and head area, or if the dog is resisting and breaking quills off, anesthesia may be required to remove them. **SEE VET.**

CAUTION: Do not pull a quill that has gone clear through the cornea. As quills can migrate under the skin and cause other complications, they should be removed promptly. However, it is okay to wait 24–48 hours before removing quills if you are in an unusual situation.

NOTE: It is not effective to cut the tip of the quill off or soak quills in vinegar.

Rx - Acepromaxine or other tranquilizer may help calm your dog so quills can be removed.

Ticks

Ticks carry a wide variety of canine and human diseases— including Lyme disease (see below).

Prevention

- Flea and tick collars; sprays and shampoos.
- Regular examination and removal of ticks.
- Cutting brush or grass where you dog plays.

To Remove Ticks

- Grasp firmly with hemostat, turn 1/4 turn to left and pull. The goal is to extract the head of the tick from beneath the skin. Left in, it can cause infection. (Spraying the tick with insecticide 10 minutes before removal may help.)

Lyme Disease

Lyme disease, caused by the bacterial organism *Borrelia burgdorferi*, can infect human beings as well as dogs. A debilitating illness, Lyme disease is now found in every state in the continental United States, though it is more prevalent in certain regions. There is a canine vaccine available for Lyme disease and it is recommended that all outdoor dogs be vaccinated on a yearly basis. Consult your vet.

Symptoms

• Lameness; swollen joints; fever; swollen lymph nodes; or acting listlessly after having ticks

Rx– If you feel your dog was exposed to Lyme disease via ticks, you could consider a course of tetracycline to treat the disease in the early stage.

Animal Pests, Insects

Drowning

Field Treatment

- Hang or suspend dog by hind legs to drain water from lungs.
- Press palms against the chest and push firmly to expel water from lungs.
- Close mouth and blow hard in nose— do this with dog suspended, if possible. Repeat.
- Keep dog's head down and try to drain as much water as possible.
- If no heartbeat, refer to CPR, below.

C.P.R. (Cardiopulmonary Resuscitation)

This procedure should be administered when the dog is not breathing and has no heartbeat (to check for heartbeat, feel behind the chest behind the left elbow). Dogs can become unconscious as a result of drowning, electrical shock, head trauma, choking, seizures, and many other conditions. Your goal is to move air in and out of the lungs while manually pumping the blood by squeezing the chest over the heart.

1. Clear airway.
2. Lay patient down on right side.
3. Close mouth and blow into nose until lungs expand.
4. Push over heart area 4 times (depress chest wall 1–2″).
5. REPEAT steps 3 and 4 *fifteen times per minute*

until dog regains consciousness or until 5 minutes have gone by.

Death Symptoms

a. Eyes do not blink when cornea is touched.

b. There is no detectable heartbeat or breathing for 5 minutes.

Snake Bite

Poisonous snakes represent a serious threat to outdoor dogs in many parts of the country. The most common are rattlesnakes of which there are several varieties. Cottonmouths, copperheads and coral snakes are also poisonous and found in certain regions of the U.S.. Because there is some disagreement among professional veterinarians on the best course of treatment for snake bite, it is recommended that you discuss this important issue with your own vet. Your vet may also dispense first aid supplies to treat snake bite.

Symptoms

• Two distinct fang marks
• Sudden yip when going through the brush
• Immediate severe pain
• Restlessness; salivation; general weakness
• Redness, bleeding—quickly turns dark in color
• Rapid swelling of infected area
• Vomiting possible; wobbly walking; seizures; rapid heart rate; pale gums; shock. (See: SHOCK., p. 27.)

Field Treatment

•• The primary goal in treating snake bite is to delay absorption of the venom. Death usually occurs when too much poison is absorbed at once.

- Calm and immobilize the dog. Do not continue hunting or hiking.
- Get to vet if possible.
- Apply a loose tourniquet (see: **Tourniquet**, pg. 41) or constricting band 2 to 3 inches above the wound (to prevent venous blood from returning quickly to the heart) but not so tight as to cut off arterial blood supply.
- Wash with antiseptic and water.
- Apply cool water or ice to cause vasoconstriction.
- Treat for shock. (see: **SHOCK,** p. 27.)
- Administer antihistamine. (See: **DOSAGE CHART**, p. 69.)

Rx– Broad spectrum antibiotic. (See: *Torn nail*, in **FEET**, p. 22.)

WARNING!

Attempting to remove snake venom by suction devices or other methods is a controversial treatment, as are attempts to neutralize venom through electrical stimulation or administration of anti-venin serums. Consult your vet about these and other snake bite treatments.

Snakebite

Fishhook Injuries

There are 2 basic causes of canine injuries related to fishhooks: swallowing a baited hook, and being hooked in the mouth, lips, or body. **If a dog has swallowed the hook (especially a treble hook), it is highly unlikely that it can be successfully pulled out.** An even more serious problem can occur if a lead weight and swivel have also been ingested as this can cause the intestines to bunch up on the foreign object. However, many single and even treble hooks (without lead weights) will pass on their own.

Swallowing baited hook
Field Treatment
WARNING!

DO NOT pull sharply on the line— this may set the hook and could tear the esophagus or stomach.

- •• If (as in the case of a backcountry fishing trip) professional vet care is not available and if the hook is deeply ingested and clearly impossible to remove, cut line and feed dog bread to dislodge.
- • Watch for signs of peritonitis. (See: **VOMITING**, p. 48.)

Hook in lip, mouth, or body
Field Treatment

- • Muzzle (see: **INTRODUCTION** for warning).
- • Push barb all the way through, cut with wire cutters, and remove hook.

DOSAGE CHART

ITEM	DOSE	USE	SIDE EFFECTS/ WARNINGS
aspirin/ bufferin	1 adult pill (5 grains) per 40 lbs. 2X/day	Arthritis/ Pain	vomiting, stomach ulcers can occur with long-term use.
calamine lotion		Soothe skin irritation	
Immodium -D	1 capsule per 50lbs 3X/day	Diarrhea	not recommended for dogs under 25lbs.
Kaopectate	1 TBS/20 lbs every 4 hrs	Diarrhea	
Syrup of Ipecac	1 tsp/10 lbs (not more than 1 TBS/dog)	Induces vomiting (i.e. poisoning)	stomach irritation/may take 15-20 min to work
salt	1 tsp in back of mouth	Induces vomiting	not always effective/ can be repeated
3% Hydrogen Peroxide	1 TBS in back of mouth	Induces vomiting and cleans infected wounds	can be repeated in 5 min. if vomiting isn't induced

cont.....

Fishhook, Dosage Chart

dosage chart cont...

ITEM	DOSE	USE	SIDE EFFECTS/ WARNINGS
Pepto-Bismol	One TBS every 2 hrs.	Vomiting	messy/ difficult to administer
Dimenhy-dramine (Dramamine)	25 to 50 mg. 1 hr. before traveling	Motion sickness	causes sleepiness
Benadryl	2 mg.per lb., every 8 hrs.	Allergies/ Snake bite	sedates dog
Betadine Solution	color water to soak wounds	disinfects wounds	do not get in the eyes
<u>Ointments</u> Bacitracin Neomycin Polymyxyn	thin coat on wound	prevents infection	
Chloraseptic Spray	One to five sprays as needed to relieve	soothes throat irritated by grass pharyngitus	

First Aid Kit/Supplies

There are several canine first aid kits available through catalogues and at retail stores. Or your vet can help you put your own kit together from among the supplies listed below.

Mail order sources:

Sun Valley Animal Center
Dr. R. Acker 1-208-726-7777

Dogs Unlimited 1-800-338-3647
Dunn's 1-800-223-8667
Foster & Smith 1-800-522-7169
Jorgensen 1-800-525-5614
T.E. Scott 1-800-989-4178

Instruments

Hemostat
Thumb forceps
Scissors/Bandage Scissors
Toenail clippers
Thermometer
Battery operated hair clippers (optional)

Cleansers/Disinfectants (nonprescription)

3% Hydrogen peroxide
Betadine-TM
Nolvasan-TM
Eyewash (Opticlear-TM)
Earwash (Oti-Clens-R)
Baby Oil or Mechanics' hand cleaner
(useful for removing tar from dog's feet)

Topical antibiotics/ointments/dressings (nonprescription)

Triple antibiotic ointment (Bacitracin, Neomycin, Polymyxin)

Calamine lotion

Nolvasan

Baking soda (bee stings)

Ophthalmic (eye) ointment

Vaseline

Stop Bleeding powder

Other medications

Enteric–coated aspirin or Bufferin

Immodium–AD

Pepto-Bismol

Dressings/Bandages

Gauze pads (4"x 4")

Gauze roll

Non-stick pads

Adhesive tape (1" and 2" rolls)

Vetwrap (bandage wrap)

Elastikon (elastic wrap)

Wet Pruf (waterproof wrap)

Misc. Equipment and supplies

Muzzle (nylon and Velcro)

Dog boots (preferably rubber)

Pad toughener

Rubber exam gloves

Elizabethan collar (to prevent scratching of eye

injuries, bandage removal, or licking and chewing of wounds)

For extended trips to remote areas where professional vet care will not be available, consult your veterinarian about the following prescription medications:

WARNING!

The medications listed below are available by prescription only from a licensed Doctor of Veterinary Medicine. They should be dispensed by and used only under the direction of your vet with appropriate instructions on applications, dosages, and precautions.

Oral antibiotics

- Ampicillin (a good all-around antibiotic to guard against infection)
- Flagyl (effective against diarrhea; also kills giardia and gram negative anaerobes)
- Tetracycline (effective against tick–borne diseases and infections)

Eye Medications

- Chloramphenicol (antibiotic ointment)
- Neobacimyx-H (R) (antibiotic/steroid ointment)
- Proparacaine (eye anesthetic—allows removal of foreign objects)
- Flouracaine (allows visualization of corneal ulcers)

Ear Medications
- Panalog (antibiotic/steroid ointment)
- Liquichlor (R) (antibiotic/steroid ointment)

Emetics (to induce vomiting)
- Apomorphine

Misc. Prescription Medications
- Prednisone (useful for treating shock, severe pain, arthritis)
- Lidocaine (anesthetic for wound suturing)
- Lomitil (useful for treating diarrhea)

Misc. Instruments and Supplies
NOTE: See your vet for a first aid course and instruction on the proper use of the following:
- Hypodermic needles
- Suturing materials
- Surgical stapler
- Otoscope

The following publications are excellent, comprehensive sources of information on canine health care matters:

The Dog Owner's Home Veterinary Handbook, by Delbert Carlson, DVM and James Giffin, MD

The Complete Book of Dog Health, by The Animal Medical Center and William Kay

Merck Veterinary Manual

ABOUT THE AUTHORS

Randall Acker, D.V.M.

Dr. Randall Acker is a 1979 graduate of the Colorado State University of Veterinary Medicine. For the past 15 years he has been practicing in Idaho's Wood River Valley, where he developed a particular interest in sporting dog injuries and orthopedic surgery. He recently opened a new clinic in Ketchum, Idaho that includes a state-of-the-art surgical facility. Dr. Acker has gained a reputation as one of the foremost canine surgeons in the region, and he has been chosen to be the official veterinarian for the 1995 National Amateur Field Trial Championship.

Jim Fergus

Jim Fergus is a freelance writer and Field Editor of *Outdoor Life* magazine, for which he writes a monthly column, "The Sporting Road." He is the author of *A Hunter's Road: A Journey with Gun and Dog Across the American Uplands.*

Wilderness Adventures Press

We publish and market fine
sporting books for the hunting
and fishing enthusiast.
Please contact us directly for
more information.

Phone; 1-800-925-3339
FAX; 1-406-763-4911